CÉZANNE

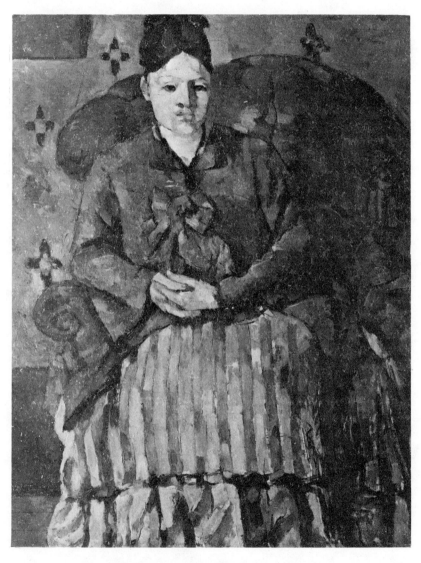

Mme. Cézanne in a Red Armchair (Museum of Fine Arts, Boston; Bequest of Robert Treat Paine, 2nd).

AMBROISE VOLLARD

CÉZANNE

Translated from the French by
HAROLD L. VAN DOREN

DOVER PUBLICATIONS, INC.
NEW YORK

Published in Canada by General Publishing Company, Ltd., 30 Lesmill Road, Don Mills, Toronto, Ontario.
Published in the United Kingdom by Constable and Company, Ltd., 10 Orange Street, London WC2H 7EG.

This Dover edition, first published in 1984, is an unabridged republication of the work as published by Crown Publishers, New York, in 1937 under the title *Paul Cézanne: His Life and Art*. A new selection of black-and-white illustrations has been made especially for the present edition, replacing the original selection, which was in black-and-white and color. A new Appendix, containing "Paul Cézanne," Roger Fry's review (slightly abridged) of Vollard's book, originally published in *Burlington Magazine*, 1917, has been added to the Dover edition.

Manufactured in the United States of America
Dover Publications, Inc., 31 East 2nd Street, Mineola, N.Y. 11501

Library of Congress Cataloging in Publication Data

Vollard, Ambroise, 1867–1939.
 Cézanne.

 Translation of Paul Cézanne.
 Reprint. Originally published: Paul Cézanne, his life and art. New York : Crown, c1937. With new appendix.
 1. Cézanne, Paul, 1839–1906. 2. Painters—France—Biography. I. Title.
ND553.C33V713 1984 759.4 [B] 84-7980
ISBN 0-486-24729-5

CONTENTS

LIST OF ILLUSTRATIONS

CÉZANNE

CHAPTER I

YEARS ago a family of poor folk, natives of Cesena, left Italy to seek their fortunes in France. Upon arriving in their adopted fatherland, the Cézannes—for they had taken the name of their native town—established themselves in the rustic Alpine city of Briançon, not far from the frontier that they just crossed. But fate being constantly against them, some of their number set out to try their luck in another region. Thus, towards the end of the eighteenth century, Louis-Auguste Cézanne, he who was to become the father of the painter, was born in a little village in the Department of Var. His parents were humble artisans, profoundly attached to their religious beliefs, and deeply respectful of ancient tradition. They had numerous children, of whom the father of our Cézanne was the only survivor. To the end of his life, Monsieur Louis-Auguste Cézanne remembered his weakly childhood with nothing but terror. Small wonder, then, that when, by dint of hard work and rigid economy, the little hatter's-apprentice became his own master, he had a loving respect for money acquired by arduous toil, and a profound aversion for the "precarious callings." In the forefront of these callings he placed the painter's craft.

Paul Cézanne came into the world on the 19th of January, 1839, at Aix-en-Provence. His father had yet to become a banker—a noble profession—the ambition of a lifetime; however, the affairs of the Cézanne hattery were going well,

and Monsieur Cézanne asked for nothing better than to see his son established some day in one of those honorable professions which are so abundantly lucrative and redound so creditably to the honor of a family. But, unfortunately, an irresistible leaning towards painting, which was to become the despair of his parents, manifested itself very early in young Paul Cézanne.

Curiously enough, his first box of colors was given to him by his father. Père Cézanne had found it among a lot of old packing cases bought at a bargain from some itinerant peddler; for Monsieur Cézanne extended the scope of his business to everything which he could dispose of at an honest profit. The father and the mother were happy to see their Paul take so readily to his pencil and colors—a peaceful amusement, which helped to calm the stormy outbursts of a personality peculiarly passionate and mobile, compounded of ungovernable violence and an almost feminine impressionability. The only person who could manage the child was his sister Marie, two years his junior, with whom he went every day, hand in hand, to a primary school where girls and boys shared the same benches.

When he was ten years of age, Paul Cézanne entered the boarding-school of Saint Joseph, a pious institution, where he learned the first elements of drawing from a Spanish monk. Three years later the young student was entered as a day-scholar at the Collège Bourbon, now the Lycée d'Aix. It was there that he met Zola, who was in a less advanced class. They became friends at once; another lad from Aix, Baptistin Baille, shared their intimacy.

Cézanne was far from being a prodigy; he acquired knowledge even less readily than the majority of children of his age; but, in spite of his violent and excessively sensitive nature, he was equally conscientious in all of his studies,

whether the classics, of which he was particularly fond, or
the sciences, towards which his spirit was decidedly rebellious.
The exception to the rule was chemistry, and he was wont
to amuse himself by repeating his experiments under the pa-
ternal roof, to the great alarm of the entire household.

In the hours of recess, Cézanne, Zola, and Baille were
inseparable. During the holidays, they roamed the fields and
the woods together. Their favorite haunts were the hills of
Saint Marc and Sainte Baume, and the Tholonet dam, an
artificial basin constructed by Zola's father upon a site whose
wild grandeur had no more enthusiastic admirers than these
three young friends. Swimming was still one of their favorite
—and one of their noisiest—diversions. Later, these amuse-
ments were augmented by pleasures of a new sort. Zola would
real aloud and comment on de Musset, Hugo, and Lamartine;
Baille would discourse and philosophize; Cézanne, full of the
names of the great colorists, Veronese, Rubens, and Rem-
brandt, would formulate theories of art. Zola's favorite poet
was de Musset; and it was Musset's verse that the young
student chose as a model for his poetical babblings. Fired by
his friend's contagious enthusiasm, Cézanne also tried his
hand at rhyme. His poetry has unfortunately disappeared—
not a trace remains; but every evidence leads one to believe
that it did not materially differ from the following lines,
scribbled much later on the back of a sketch for the
Apotheosis of Delacroix:

> Behold this young girl whose garment reveals
> Her plump, buxom form in the midst of the fields;
> Her body so supple, so splendidly blown,
> No serpent has ever more suppleness shown.
> The sun catches her in its luminous mesh,
> And with golden rays caresses her flesh.[1]

[1] Voici la jeune femme aux fesses rebondies!
Comme elle étale bien au milieu des prairies;

Cézanne was not a poet only; he aspired to be a musician as well. A friend, Marguéry by name, took it into his head one day to organize a band at the Collège d'Aix. Cézanne, Baille, and Zola enrolled immediately. After the academic procession, the band would march triumphantly through the city, and one might have seen Cézanne tooting a cornet with all his might and main, while Zola, with a clarinet, brought up the rear. Zola became such a virtuoso that he obtained the honor of playing behind the dais on procession days.

Outside of school hours Cézanne pursued the courses in drawing and painting which were given at the Municipal Museum. Already he was astonishing his comrades by the unexpected audacity of his interpretations. His dream of art was beginning to take shape, and his mother, in whom he confided his hopes and plans, was not slow to encourage him.

Elizabeth Aubert, Cézanne's mother, was born at Aix of a family of remote Creole origin. She was vivacious and romantic, carefree in spirit, but endowed with a disposition at once restless, passionate, and quick to take offense. It was from her that Paul got his conception and vision of life. Happy at finding herself regenerated in her son, she pleaded in his behalf with his father. But, in spite of an argument which she had contrived in her mother's heart, and which she adjudged unanswerable—"His name is Paul, isn't it, the same as Veronese and Rubens?"—it was not without anxiety that Monsieur Cézanne observed artistic proclivities developing in his son.

A second prize in drawing brought back by young Paul from the Aix School of Fine Arts at the age of nineteen,

Son corps souple, splendide épanouissement!
La couleuvre n'a pas de souplesse plus grande,
Et le soleil qui luit darde complaisamment
Quelques rayons dorés sur cette belle viande.

further increased the father's apprehensions. He was pained and at the same time astonished that the son of a financier (for Monsieur Cézanne had some years earlier realized his dream of becoming a banker) should take pleasure in such silly trash, and he never tired of saying: "Young man, young man, think of the future! With genius you die, with money you live!" [2]

However, the situation had not yet become desperate. Paul Cézanne had pursued his classical studies in spite of his great passion for painting, and had succeeded in getting his degree in letters in the same year that he had taken his second prize in drawing. (The boy who took the first prize, and who was later to become an estimable local painter, never forgave Cézanne for having secured in the eyes of the world the place which he felt belonged to him as winner of the first prize.) But for all his violent nature, Paul Cézanne was quite the reverse of rebellious where his father was concerned. He even manifested considerable timidity in the presence of the author of his days. But he suffered all the more acutely because of the hostility he encountered all about him, and perhaps would have succumbed to discouragement—Zola having been called away to be with his mother, lately widowed and settled in Paris—had not his friend Baptistin Baille remained at Aix. Baille, although devoted to algebra, discussed poetry and painting as fervently as ever.

As for Zola, he was very unhappy in Paris. His schoolmates at the Lycée Saint-Louis scorned him for his lack of worldly goods and his provincial manners: so he jumped at the chance of spending his vacation at Aix during the summer of 1858, and the walks to Tholonet and Roquefavour were

[2] Words of M. Louis-Auguste Cézanne quoted to Paul Cézanne by Zola in a letter published in *The Correspondence of Emile Zola, Early Letters,* Fasquelle, 1907. All passages quoted in this book from Zola's letters are likewise borrowed from this collection.

resumed. Cézanne, obliged to hide from his father's watchful eye when he was busy at his painting, was only too happy to show his sketches to his friend. Zola told of his plans and read his first efforts; Baille criticized them. In the end they got so worked up over literature that, by the time the holidays were over, friend Baille, fearing to be repudiated by his comrades should they find him incapable of "expressing himself by means of some form of art, be it painting or poetry," even talked of renouncing algebra to consecrate himself to rhyme.

But Cézanne had graver preoccupations. His father refused to recognize painting as a serious vocation; nor would he acknowledge it a possible source of daily bread. Again Paul had to give in. He registered with the Law Faculty at Aix (1858–1859) and even passed the first examination without difficulty, in spite of such a distaste for it that, to make the task more interesting, he put the codes into French verse.

Zola came back to Aix during the summer of 1859 for a visit of four months; once more the three friends resumed their rambles together, their intimacies deepened, plans for the future took shape.

The holidays over, Cézanne turned to his law books more reluctantly than ever, and Zola went back to Paris. Cézanne had visions of joining him there, but his painting master, Monsieur Gilbert, was not going to let a pupil slip away from him without an effort; in that quarter, the elder Cézanne found unforeseen aid in holding on to his son. As a matter of fact, the eventuality of a departure for the capital worried him not a little, and he feared both the influence of Zola upon his son and the thousand and one dangers of Paris. Having lived there for a few years in his youth, he cherished the memory of a city where swindlers and sharpers abounded —had, in fact, the upper hand. Zola paid no attention to mis-

givings of that sort. He had drawn up a budget for his friend on the basis of 125 francs a month, a sum which, in view of what it was to pay for, would surely not exceed the limits of Monsieur Cézanne's generosity:

"A room at twenty francs per month; *déjeuner* eighteen sous and dinner twenty-two sous, making two francs a day or sixty francs a month; adding the twenty francs for the room—that makes eighty all told. Besides that, you have your studio class to pay for; Suisse's, one of the cheapest, costs ten francs, I believe. Then I should say ten francs for canvas, brushes and paints, which makes one hundred francs. That leaves you twenty-five francs for your laundry, light, tobacco, pocket-money, and all the thousand and one little needs that come up from day to day. But there are additional resources that you can create for yourself. Studies done in the schools, above all, copies made in the Louvre, sell very well. . . . All you have to do is to find a market, which is merely a question of looking."

Cézanne took up his law books dejectedly. But Zola in his letters did not simply confine himself to reiterating the inducements that Paris had to offer; he plunged boldly into the unsounded seas of art.

"We often talk poetry in our letters, but the words 'sculpture' and 'painting' seldom if ever crop up in them. It is a grave omission, almost a crime. . . ."

Zola had already written to Cézanne about Greuze: "Greuze has always been my favorite." He had confided the uneasiness stirred within him by an engraving of Greuze representing "a young peasant girl, tall and with rare beauty of form." He knew not which to admire the more, "her willful face or her magnificent arms."

Another time he wrote of Ary Scheffer, "that painter of pure, aërial, almost diaphanous types"; and he profited by

the opportunity to inform Cézanne that "poetry is a great thing; there is no salvation but in poetry."

Zola brought his letter to a close by recommending that his friend "work for strong and firm drawing—*unquibus et rostro*—so as not to become a realist, but to be a Jean Goujon or an Ary Scheffer."

And then, after having put Cézanne on his guard against realism, Zola pointed out another pitfall, one of the most perilous, namely: "commercialized art." One of their old comrades had fallen victim to it, a chap with whom they should have nothing further to do. "Above all (and here lies the gravest danger), do not admire a picture because it has been done quickly; to sum up in a word, do not admire and do not imitate a painter who has sold his art."

Zola so feared a like fate for his friend that he reverted perpetually to his favorite subject, begging forbearance if he pressed needless precautions upon Cézanne. But "friendship alone dictated his words"; and besides, his ignorance of the painter's craft gave him a real advantage over Cézanne, because, knowing at best only "how to distinguish black from white," he would not "be tempted to bother about the technique," whereas he feared that Cézanne, who knew "how difficult it was to place the colors just where he wanted them," might in spite of himself be intrigued into seeing only "pulverized colors applied to a canvas," and "to search constantly for the mechanical method by which the effect was obtained." (There's a grave danger for you!) But, on condition that one first placed the idea above everything, Zola conceded that one might then deign to become interested in the "rough, oily surface of the canvas"; in a word one must know one's business.

"Far be it from me to disdain form! That would be folly, for, without form, one might be a great painter as far as

oneself were concerned, but not for others. It is by form that the painter is understood, appreciated."

Cézanne *père* was at last forced to admit his son's incapacity for everything connected with "temporal" affairs. Yielding finally to the importunities of the young man and the prayers and lamentations of his wife, he gave his consent to Paul's departure for Paris, with the secret hope that he would not prosper with his painting and that he would return to the bank.

So at last, in 1861, Cézanne, escorted by his father and his sister Marie, arrived in the capital. All three found lodging at a hotel in Rue Coquillière. After making a few calls on old acquaintances, the father and sister returned to Aix, and Paul found himself free at last, provided with a small credit account on the house of Le Hideux, the Paris correspondent of the Cézanne-Cabassol bank at Aix. Cabassol was a cashier whom Monsieur Cézanne had elevated to the dignity of a partner, on account of his practical view of life. Instead of sowing wild oats, Cabassol had consecrated all his spare time, which he passed at the Café Procope (the business men's rendezvous at Aix), to a careful study of the credit of his fellow-townspeople. Such was the accuracy of his information, that, when a borrower would appear at the window, Monsieur Cézanne, in order to be assured of his solvency, had only to turn to the faithful Cabassol and inquire, "You hear what the gentleman wishes; have you the money in the safe?"

CHAPTER II

PARIS

(1861–1866)

THE moment he arrived in Paris, Cézanne rushed off to see Zola.

"I've seen Paul!!!" wrote the future author of *L'Oeuvre* [1] to their mutual friend Baille. "I've seen Paul; do you realize that? Do you comprehend all the melody contained in those three words?"

At that time Zola lived in Rue Saint-Victor, near the Panthéon. In order to be near to him, Cézanne rented a furnished room in Rue des Feuillantines. By day Zola worked at the docks where he had some small job, while Cézanne attended the Académie Suisse [2] on the Quai des Orfèvres. But at night without fail the two would meet again in Zola's room and

[1] *L'Oeuvre*, published by Zola in 1867, has for its central figure Claude Lantier, who was drawn in part from Cézanne, and in part from another of the group of Impressionist painters, Bazille, who was killed in the Franco-Prussian war.

[2] Gustave Coquiot, in his volume *Cézanne* (Librairie Ollendorf, Paris 1919), gives some illuminating details about the Académie Suisse: "Today the Académie Suisse is no more; it has disappeared along with the office of Sabra, the popular dentist, who was for a long time established at the end of Pont Saint-Michel. The additions to the Palais de Justice crowded out this picturesque corner of Paris.

"The Académie Suisse and Sabra's "dental parlors" were on the same floor, and in consequence more than one amusing mistake occurred. It was only the patients who were offended; many of them fled, never to return—having opened the wrong door by mistake—when they found nude models shamelessly walking about the room.

"The Académie Suisse was a free and easy school. Nobody came to give criticisms. It opened very early, about six A. M. in the summer; then, the afternoon class over, there was a period from seven to ten o'clock in the evening. Three weeks out of each month, there was a male model; the other week, a female model." (*Trans. Note*)

talk art and literature as in the good old days at Aix. Zola even posed for a portrait; but it did not "go" well at all, and the young painter, already quick to be discouraged, lost no time in destroying the canvas.

"I've ripped it to pieces; your portrait, you know. I tried to work on it this morning, but it went from bad to worse, so I destroyed it. . . ."

But it appears that the intimacy they shared was not proving as successful as they had hoped. In all probability their ideas about painting were too much at variance, and perhaps "to chat as of old, their pipes aglow and their cups brimming" did not strike Cézanne as the "glorious consummation" that Zola had imagined. In a letter dated 1862 Zola wrote: "Paris has not fostered our friendship. . . . Never mind, I shall always count you my friend."

Cézanne received this letter while at Aix. Weary of Paris, he had felt the need of contact with his native soil. A surprise was waiting for him there. His father, who had less faith in painting than ever, would not hear of Paris again, and took him into the bank. "Hush! my dear Paul, what good can painting do you? How can you hope to improve on what Nature has already done so divinely well? You must be very, very stupid!"

Yielding as usual to the paternal will, Cézanne tried to take an interest in book-keeping. To break the monotony of the toil to which he was condemned, he covered the margins of the ledgers with sketches and rhymes. This couplet is all that remains:

> The banker Cézanne, with fear in his eyes,
> Sees a painter-to-be from his counter arise.[3]

[3] Cézanne, le banquier, ne voit pas sans frémir
Derrière son comptoir naître un peintre à venir.

Unable for long to turn a deaf ear to the whisperings of the muse, he escaped now and then from the offices and repaired to the Jas de Bouffan,[4] where he painted vast compositions on the walls of one of the rooms. Four of the panels were so large that, for a joke, he signed them Ingres, and dated them "1811."[5]

But at last came the day when his father, unable longer to oppose such a manifest talent without laying himself open to the charge of persecution, allowed Paul to return once more to Paris. Cézanne was overjoyed to see his dear friend Zola once more. As far as he was concerned, their separation had wiped away all the misunderstanding and coolness of the past. He secured a room in Boulevard Saint-Michel, opposite the School of Mines, attended the Académie Suisse once more, and became acquainted with Pissarro, Guillaumin, and Oller. Through Oller he made the acquaintance of Guillemet.

Although he still maintained affectionate relations with his family, they occasionally came to loggerheads over "this confounded painting." He was impatient to take the measure of his talent and presented himself for the entrance examination to the Ecole des Beaux-Arts. He did not pass. Monsieur Mottez, one of the examiners, when asked to give a reason, made this statement: "Cézanne has the proper temperament for a colorist; unfortunately his work is extreme."

After this setback, it was with some apprehension that the ill-fated candidate watched the hour approach when he would have to return to Aix for his vacation. His friend Guillemet accompanied him to plead the painter's cause with his father. But the elder Cézanne had made up his mind; he would

[4] The Home of the Winds. A beautiful house and garden near Aix owned by Monsieur Cézanne. Paul Cézanne preferred to work there to the end of his life.

[5] Many other compositions had been painted on the walls of this same room. The space being limited, Cézanne painted one subject over another.

never again try to turn his son aside from the path he had
followed with such obstinate determination.

After a few months spent at Aix, Paris once more. He
rented a studio in Rue Beautreillis, near the Bastille. There
he painted several notable still-lifes, among them the *Bread
and Eggs,* as well as a large study for *Women Bathing* in-
spired by Rubens. (This is the *Bathers* of Zola's hero Claude
Lantier.)

An old painter who knew Cézanne at this time, said of
him: "Yes, I remember him well! He used to wear a red vest
and always had enough money in his pocket to buy a friend
a dinner."

Indeed, it was Cézanne's practice. when he had money in
his pocket, to spend it before going to bed. *"Pardieu!"* he used
to exclaim to Zola, who found him prodigal, "if I should die
tonight, would you want my family to inherit the money?"
Besides being improvident, he was incurably bohemian. His
friends tell how, in the course of his promenades, he would
take it into his head to stretch out full length on one of the
benches scattered about in the vicinity of the Luxembourg
Gardens, and how, for fear that some thief might relieve him
of his shoes while asleep, he would use them for a pillow!

These stories were the despair of Zola, who was for the
bourgeois comforts every time, and had his reception day with
tea and cakes. In addition to Zola's daily visitors, Cézanne
and Baille (who was now pursuing his scientific studies at
Paris), there were several others who had joined his circle.
Anthony Vallabrègue, a young poet from Aix, was among
them. Then there was Marion, another Provençal, whose
ambition it was to be a painter, but who was destined in the
end for a chair of sciences; and lastly Guillemet and Marius
Roux, a very elegant young man, so neat and so preternatu-
rally immaculate that Zola used to say of him, with an ad-

miration not unmixed with irony: "You never see the marks of *his* knees on his trousers!"

It is not hard to picture the temperaments of Zola, Baille, and Cézanne at that time. The first was shrewd and self-possessed; the second dreamed of making a good position for himself in the world; Cézanne was the "shuddering and tormented one of the three." [6]

From his first visits to the Louvre, the young painter gathered only confused impressions, overwhelming visions of light and color. To use his own expression, the pageant which unfolded before his eyes seemed like a "luminous, colored pudding." Rubens above all amazed him. Under his influence, Cézanne designed great compositions in fulgurant color. Zola, who had put his friend on his guard against realism, now found that he went to the other extreme, exalted romanticism. Whereupon Cézanne, to offset this tendency, set about to paint droll and pseudo-realistic little canvases, like the *Woman with a Flea*. This picture has disappeared, together with another of the same period representing a nude man sleeping on a folding bed. The model who posed for this *académie* was an old night-man, whose wife kept a little creamery where she served a beef soup much appreciated by her ravenous young patrons. Cézanne, who had won his confidence, asked him to pose. The night-man reminded him of his "job."

"But you work at night,—you have nothing to do in the day-time." The other demurred, saying he slept during the day.

"Well then, I'll paint you in bed."

The old codger was promptly put under the covers, with a neat night-cap on his head in honor of the painter. But since it was not worth while to bother about the proprieties

between friends, he took off the bonnet first, then threw back the covers, and finally posed quite nude. His wife appeared in the picture, handing a bowl of warm wine to her husband.

The prevailing opinion in critical circles about Cézanne's method was that he simply aimed a pistol loaded to the muzzle with variegated colors at a blank canvas. Thus his manner came to be dubbed "pistol-painting." In truth, Cézanne would have been the last to try to prove to the public that there was anything further in his work than accidental effects; but, if he knew how to paint pictures, he had no gift for explaining them or for providing them with appropriate names. For the study of the night-man, his friend Guillemet came to his rescue by devising the title, *An Afternoon at Naples,* or *The Wine Grog.* The other studies of the same theme are much later than this picture, which was painted in 1863.

This same year Cézanne made the acquaintance of Renoir. One day the door of Renoir's studio opened, and he beheld one of his friends, Bazille, accompanied by two strangers whom he presented with the words: "I am bringing you two distinguished recruits." They were Cézanne and Pissarro. Cézanne also met Manet about this time. He and Zola were introduced to him by Guillemet. Cézanne was at once struck by Manet's skill in "realization." "He hits off the tone!" he exclaimed; however, after a moment's reflection, he added, "but his work lacks unity—and temperament too."

In most cases decisions of this sort had become quite simple for Cézanne. He had divided painting into two kinds: "husky" [7] painting, of the sort that he himself hoped some day to "realize," and "emasculated" painting, that of the "others." In this second category he placed Corot, of whom Guillemet never wearied of talking. Cézanne interrupted him

[7] *Couillarde.*

one day with: "Don't you think your Corot is a little short
on temperament?" Then he added: "I'm painting a portrait
of Vallabrègue; the high-light on the nose is pure vermillion!"

But, if we know *The Woman with a Flea,* the *Afternoon
at Naples,* and the *Bathers* only by hearsay, other more in-
teresting canvases of the period of his youth are still extant:
The Judgment of Paris (1860), *a Self-Portrait* (1864) *Por-
trait of Vallabrègue* (1865), *Portrait of the Negro Scipio*
done at the Atelier Suisse in 1865, *Portrait of Marion* (1865),
Bread and Eggs (1865), which we have already mentioned,
and others.

CHAPTER III

CÉZANNE ASPIRES TO THE SALON OF BOUGUEREAU
(1866–1895)

IN 1866 Cézanne resolved to brave the official Salon. He selected *An Afternoon at Naples* and *The Woman with a Flea,* both of which, in his judgment, could be understood by the "bourgeois" on the jury. Cézanne, penniless on that particular day, was in no position to pay for the services of an agent. Taking the bull by the horns, he loaded his canvases on a little cart, and, assisted by some obliging friends, he set off towards the Palais d'Industrie. His arrival at the Salon, surrounded by his young artist friends, created a sensation; he was borne in triumphantly.

Need we say that the jury did not share their enthusiasm? The pictures were refused, whereupon Cézanne entered a protest with Monsieur Nieuwerkerke, the superintendent of the Beaux Arts. There was no reply, so the painter again took up the cudgels with the following letter:[1]

April 19, 1866

Monsieur:

Recently I had the honor of writing to you upon the subject of two of my canvases which the jury have just refused.

Since you have not yet replied, I feel I must lay further stress upon the motives which caused me to address myself to you. As you have doubtless received my letter, I need not repeat here the arguments which I felt obliged to put before you. I shall content myself with saying again that I cannot accept

[1] Archives of the Louvre, X, 21, 1866.

the ill-considered judgment of people whom I myself have not appointed to appraise me.

I write to you again, then, to fortify my demand. I appeal to the public, and wish to have my canvases exhibited in spite of the jury. My desire seems to me to be only right and proper; and if you will ask any of the painters who find themselves in my position, you will find that not one of them has any use for the jury, and that they would like to participate in one way or another in an exhibition which should be compulsorily open to every serious worker.

Let the Salon des Refusés be re-established then. . . . Should I find myself alone in this demand, I sincerely desire that the public at least know that I can no longer stand having to do with these gentlemen of the jury who, it would appear, wish to have nothing to do with me. I hope, Sir, that you will not choose to remain silent. It seems to me that any seemly letter merits a reply.

Accept, I beg you, the assurance of my most cordial regard.

PAUL CÉZANNE

22 Rue Beautreillis.

This time a reply was forthcoming; the following note was written on the margin of the painter's letter:

What you ask is impossible. We have now come to realize how much beneath the dignity of art the exhibition of the Refusés was in the past, and it will not be re-established.

It is readily seen how, from the first, a hostility that nothing ever seemed to mitigate began to be manifested against Cézanne in the ranks of officialdom. But a little later he was to have his revenge. Zola had been commissioned by *l'Evénement* to write up the Salon of 1866. With the aid of detailed notes turned over to him by Guillemet, he wrote articles about Meissonier, Signol, Cabanel, Robert Fleury, Olivier Merson, Debufe, and many others. His criticisms were so scathing that the publishers had to delete the Salon articles

from the paper. Cézanne could not contain his joy. "Nom de Dieu!" he repeated over and over again, "hasn't he roasted those damned fools to a turn?"

It was that year, 1866, that the gatherings at the Café Guerbois began. Manet, Fantin, Guillemet, Zola, Cézanne, Renoir, Stevens, Duranty, Cladel, and Burty, to mention only a few, were in the group. It was Guillemet who introduced Cézanne to the Café Guerbois; but from the beginning Cézanne was decidedly not one of them. "They're not worth a cent," he said to Guillemet. "They dress themselves up like a pack of lawyers!" By way of showing his disapproval, he played the cynic. Once when Manet asked him what he was preparing for the Salon, Cézanne flung back, "A pot of s——."

During the latter months of the year 1866, Cézanne, who after the Salon had gone to spend a few days with Zola at Bennecourt on the banks of the Seine, made a trip to Aix, and at the Jas de Bouffan painted the portrait of his father seated in an armchair reading his paper. Of the same period there is the portrait of Achille Emperaire; *l'Enlèvement* came a little later; and lastly, in 1868, he executed *The Feast,* directly influenced by Rubens, and *Leda and the Swan,* which he composed after an engraving. The idea of this last composition was suggested to him by the famous painting of Courbet, *The Woman with a Parrot.* Upon seeing this picture, Cézanne exclaimed, "I'm going to do a *Woman with a Swan."* Another nude, in the same pose but without the Swan, and less archaic in form, was painted more than ten years later in preparation for a projected illustration for *Nana.*

One day I asked Cézanne what sort of a life he and Zola had led during the war. He replied: "Listen, Monsieur Vollard, I worked a lot out of doors at Estaque. Except for that there was no other event of importance in my life during the years 1870-71. I divided my time between the field and the

studio. But if I had no adventures during those troubled years, things didn't go so smoothly with my friend Zola, who went through all sorts of avatars, especially after his final return from Bordeaux to Paris. He had promised to write me as soon as he arrived there. It was only after four long months that he was able to keep that promise.

"Due to the refusal of the government at Bordeaux to accept the offer of his services, Zola decided to return to Paris. The poor fellow arrived towards the middle of March, 1871; a few days afterwards the insurrection broke out. For two months he didn't do very much; cannon night and day, and, towards the end, the shells whistled over his head and landed in his garden. Finally, in May, threatened with being taken as a hostage, he fled with the aid of a Prussian passport, and went to 'dig in' at Bonnières. . . . Zola is very hardy! After the Commune, when he found himself again comfortably situated in the Batignolles, all those terrible events which he had taken part in seemed nothing more to him than a bad dream.

" 'When I behold,' he wrote to me, 'that my house has not budged an inch, that my garden is just the same as it ever was, that not a chair, not a plant has suffered, I am at last able to persuade myself that the two sieges are nothing but "bogey-man" stories contrived to frighten little children.'

"I'm sorry, Monsieur Vollard, that I didn't save that letter. I should like to have shown you a passage where Zola says 'what a pity that all fools are not dead and buried!'

"Poor Zola! He would have been the first to suffer if all fools were dead! Just for fun, I reminded him once of that phrase of his. It was on one of the last evenings that I spent with him. He had told me that he was going to dine with some noted personage to whom he had been presented by Monsieur Frantz Jourdain. I couldn't help saying: 'Just the

same, if all fools were dead and buried, you would have to
sit at home and eat your left-over stew with your house-
keeper!' And would you believe it, my old friend couldn't
see the joke at all!

"Hadn't I earned the right, Monsieur Vollard, to joke a
bit with a man when I'd worn out my pants with him on the
same benches at school?"

Cézanne continued: "Zola closed his letter by urging me
to come back to Paris too. 'A new Paris is about to be born,'
he wrote; 'it is our turn now!' Our turn now! Zola was a
little too sanguine, I found; at least as far as I was concerned.
But all the same, something told me to go back to Paris.
It was too long since I had seen the Louvre. But understand,
Monsieur Vollard, I was working at that time on a landscape
which was not going well. So I stayed at Aix a little while
longer to study on my canvas."

Shortly after his return to Paris (1872), Cézanne met
Doctor Gachet, an ardent admirer of modern painting. The
revolutionary tendencies that this excellent man thought he
scented in Cézanne's art enraptured him, and he vigorously
urged him to come and paint at Auvers, where he himself
worked. He confessed confidentially to Cézanne that he him-
self had begun to try a hand at painting from the very day
that it had been given to him to see clearly what painting
was all about. Delighted to find one of the "initiated" so
cordial, Cézanne followed his confrère to Auvers, where he
remained for two years. His parents redoubled their efforts to
make him come back to them, but in vain. The young painter
was deaf to their appeals—for many reasons. Some of them
are explained in this fragment from one of his letters:

"At Aix I am not free; whenever I want to return to Paris,
I always have to put up a fight, and, although your opposition
may not be absolute, I am always deeply affected by the resist-

ance that I encounter from you. I sincerely want my liberty unfettered and I shall take all the more joy in my freedom when I feel that I can hasten my return to your midst; it would give me great pleasure to work in the Midi, some aspects of which offer many resources to the painter; there I would be able to attack some of the problems that I wish to solve. . . ."

Pissarro, who was also working at Auvers, cautioned Cézanne not to let himself be dominated by the Masters. Under the influence of his friend's advice, Cézanne resolved, although not without a struggle, to subdue the romantic side of his temperament. It was then, properly speaking, that the inward conflict between two opposing tendencies began to be waged.[2]

After the war, the Café Guerbois was forsaken. The former habitués of the place congregated now at the Nouvelle Athènes. Cézanne said to me one day about Forain, whom he met there—a Forain still quite young: "He knew how to suggest the folds in a coat even then, the beggar!"

At the Nouvelle Athènes, as at the Guerbois, Manet was the dominating personality. In 1870 Fantin-Latour painted a famous group of some of the faithfuls of the Café Guerbois gathered about Manet who sits before his easel. In this picture, the impression is decidedly that of a master surrounded by his disciples. Cézanne alone continued to express his distrust of the extraordinary facility manifested by the painter of the *Olympia*. "A good job, though," he would say, in speaking of this canvas which, as we know, he tried to match with a new *Olympia,* more modern in treatment. Manet was

[2] I have not spoken of the canvases painted between 1869 and 1873. I might mention *Temptation of St. Anthony,* 1870; *Outdoor Scene,* in which the painter depicts himself stretched out on the ground, 1870; *The Promenade,* 1871; *The Red Roofs,* 1869; *The Modern Olympia,* 1872; *Man with a Straw Hat,* 1872; *The House of the Hanged,* 1873; *The Cottage in the Woods,* 1873; *Temptation of St. Anthony,* 1873.

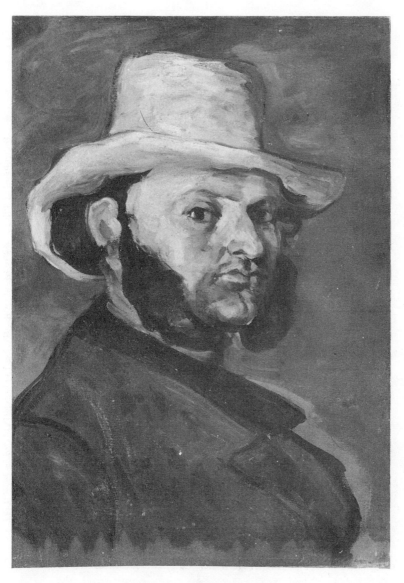

Man in a Straw Hat (The Metropolitan Museum of Art, New York; Bequest of Mrs. H. O. Havemeyer, 1929; the H. O. Havemeyer Collection).

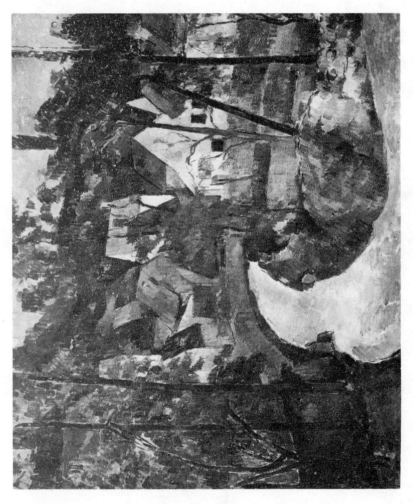

The Turn in the Road (Museum of Fine Arts, Boston; Bequest of John T. Spaulding).

equally hostile towards the author of *An Afternoon at Naples*. He did not beat around the bush about it either, as evidenced by his remark to Guillemet about Cézanne: "How can you abide such foul painting?"

I have asked some of the surviving painters of this period how Manet, who copied the Spaniards, and later abandoned his magnificent blacks to follow in the wake of Monet and Impressionism, could have been hailed as the leader of a school. "Because," they would reply, "procedure counts for little in art. What made Manet a veritable prophet in his day, was that he brought a simple formula to a period in which the official art was merely fustian and conventionality. You know the saying of Daumier: 'I do not like Manet's work at all, but I find that it has this great quality: it takes us back to the figures on playing cards.'"

Cézanne had never talked about Manet in any but a joking or whimsical vein. One day, however, I met him by chance in the Luxembourg, standing before the *Olympia,* and I hoped that on this occasion he would express his opinion of his contemporary more fully.[3] Cézanne was with Guillemet: "My friend Guillemet," he explained, "wanted me to look at the *Olympia* again. . . ."

I informed Cézanne that there was talk of putting this canvas in the Louvre. At the word "Louvre" Cézanne started: "But just listen a minute, Monsieur Vollard! . . ."

He broke off. His attention had been suddenly diverted by the gesture of a gentleman who, in leaving the room, waved a friendly salutation towards the *Floor Planers* by Caillebotte. Cézanne burst out laughing. "It's Carolus! At last he realizes that he put his foot into it by following Velasquez! . . . Any one who wants to paint should read Bacon. He defined the

[3] This conversation took place in 1897. (*Trans. Note*)

artist as *homo additus naturae.* . . . Bacon had the right idea.
. . . But listen, Monsieur Vollard, speaking of nature, the
English philosopher didn't forsee our open-air school, nor
that other calamity which has followed close upon its heels:
open-air indoors! . . ."

Two people had stopped before Cézanne's landscapes,
which were hung farther along the wall. I pointed them out
to the master. He glanced at them, and stepped closer to me:
"You know, Monsieur Vollard," he said in a low tone, "I've
learned a lot through the portrait I'm doing of you. . . .[4] At
last they're putting frames on my pictures!"

Returning to Carolus-Duran, whose conversion to Impres-
sionism was ever an inexhaustible subject for reflection and
comment with him, he remarked: "The beggar! he has
chucked the Beaux-Arts! . . . Perhaps the poor chap can't
find any one to buy his pictures any more!"

Guillemet: Just to think that the former triumphs of
Carolus-Duran made even Manet jealous! One day Astruc
buttonholed him and said, "Manet, why are you so critical
with your friends? . . ." "My dear fellow," Manet replied,
"if only I made a hundred thousand francs a year like Caro-
lus, I could find genius in everybody, even in you and
Baudry!"

Myself: Do you remember Manet's remark to Aurelien
Scholl, who was bragging about his influence with *Figaro?*—
"Well then, have them put me down in the obituary column!"

Cézanne: Listen, Monsieur Vollard, Parisian wit gives
me a pain. . . . Excuse me, I'm only a painter! . . . Painting
nudes on the banks of the Arc[5] is all the fun I could ask for.
Only, you understand, all women are cats and damned cal-

[4] See Chap. VIII.
[5] A river near Aix-en-Provence.

culating. . . . They might get their hooks on me![6] Life's frightful, isn't it?

Guillemet (pointing to the *Olympia*): Victoire was the model who posed for that picture—what a fine girl she was; and *so* amusing!

One day when she came to Manet's studio she said, "Listen, Manet, I know a very charming young person, the daughter of a colonel. You ought to do a picture of her——the poor child is hard up. But take care, she was brought up in a convent, and she knows nothing of life, so you must treat her with all the respect in the world, and see that you don't say anything you shouldn't." Manet promised to be on his very best behavior. The following day, Victoire arrived with the officer's daughter and said to her without so much as a wink, "Come, my dear, show the gentleman your chemise!"

Cézanne did not seem to relish this playful little story at all. He walked away with a preoccupied air. Doubtless he was haunted by his notion that women were "all cats and damned calculating."

[6] A literal translation of this expression, one of Cézanne's favorites, would be, "They might put the grappling hook into me." Cézanne meant by it, simply, that they might disturb him so that he would be unable to work. (*Trans. Note*)

CHAPTER IV

THE EXHIBITION OF THE IMPRESSIONISTS

IN 1874 Cézanne participated in the exhibition of the Society of Painters, Sculptors, and Gravers at the Nadar Photographic Galleries, 35 Boulevard des Capucines. There were thirty in the group, which included Pissarro, Guillaumin, Renoir, Monet. Berthe Morisot, Degas, Bracquemond, de Nittis, Brandon, Boudin, Cals, G. Colin, Latouche, Lépine, Rouart, and several others, all more or less "innovators." This exhibition enjoyed the same sort of success as had the Salon des Refusés. But the public found occasion to protest from another point of view entirely. While you might see the Salon des Refusés, an annex to the official salon, free of charge, you had to dig into your pocket to see the "Impressionists"!— for that was the name the public bestowed with one accord upon this group of painters after seeing a Monet in the exhibition entitled *Impression.*

Cézanne had the surprise of his life when he found that a collector had taken a fancy to one of his canvases and had purchased it. *The House of the Hanged* today in the Louvre —was acquired by Count Doria, who had already given evidence of the liberality of his tastes by discovering Cals and Gustave Colin; but must I add that the "extravagant" acquisition of Cézanne's picture resulted in discrediting this amateur in the eyes of the "connoisseurs" of his set?

Three lears later, in 1877, Cézanne exhibited again, with several members of the same group, in a vacant flat at 6 Rue

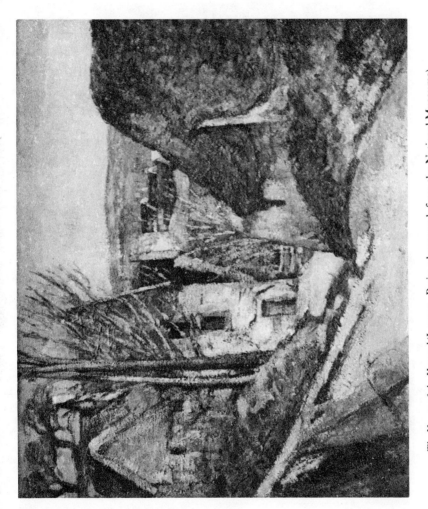

The House of the Hanged (Louvre, Paris; photograph from the National Museums).

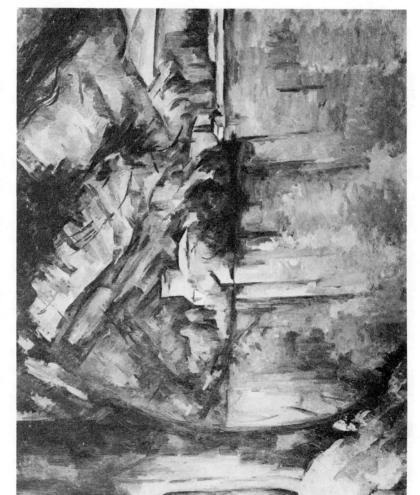

Le lac d'Annecy (Courtauld Institute Galleries, London).

Lepeletier. On this occasion the exhibitors, at the suggestion
of Renoir, unhesitatingly adopted the name of Impressionists.
They did not pretend to be offering a new kind of paint-
ing; they simply confined themselves to telling the public
honestly, "Here is our work. We know you don't like it. If
you come in, so much the worse for you; no money refunded."
But words are so tyrannical that the public came to believe
that the new word signified a new school, a misapprehension
which persists even to this day. Renoir once said to me: "They
think we are nothing but makers of theories—we whose only
object, like the old masters, is to paint with clear and joyous
colors!"

As for Cézanne, need I add that his pictures at this ex-
hibition again aroused universal condemnation? Huysmans
himself, although he extolled the artistic honesty of Cézanne's
work, alluded to a "disconcerting absence of balance; houses
leaning over to one side like drunken men; deformed fruit in
tipsy bowls. . . ."

Although painting was Cézanne's dominating passion to
his dying day, the masterpieces of literature were far from
leaving him unaffected. His predilections were for Molière,
Racine, La Fontaine; among the contemporary writers he
gave high rank to the Goncourts, Baudelaire, Théophile
Gautier, Victor Hugo—in a word, to all those who expressed
themselves in color-images. He even went so far as to compose
a verse as a tribute to Gautier, inspired by a poem that the
latter had written in honor of Delacroix:

"Gautier, le grand Gautier, le critique influent."

Cézanne had become one of a group of poets and artists
who gathered from time to time at the home of Nina de

Villard. At Nina's there was a warm welcome for everyone
and not the slightest trace of formality; they would crowd
themselves to make room for you at the table; there was al-
ways something to smoke. It was here that Cézanne met
Cabaner, one of his admirers from the very first.

Cabaner was a good fellow, something of a poet, a fair
musician, a bit of a philosopher. It is only too true that For-
tune had not smiled upon him; however, he was jealous of
no one, so strong was his faith in his musical genius. None
the less he was inwardly convinced that Destiny, fickle as we
know her to be, would cause him always to be misunderstood.
Therefore he resigned himself to his fate with good grace. "I
will be remembered," he liked to say, "as a philosopher."
Many of his sayings have become traditional. "My father,"
he once remarked, "was a man of the Napoleon type, but not
so stupid." And another time, "I didn't know I was so well-
known. I was saluted yesterday by all Paris." He did not add
that he had been following a funeral procession. During the
siege of Paris, when the shells were dropping like rain, Ca-
baner inquired innocently of Coppée, "Where do all those
bullets come from?" Coppée was stupefied. "From the enemy,
most likely," "Is it always the Prussians?" Coppée, beside him-
self: "Well, who do you think they are?" Cabaner: "I don't
know. . . . perhaps other tribes. . . ."

In his own field of music, Cabaner's witticisms were no
less original. One evening he had played a selection of Gounod
after one of his own compositions; when the applause was
over, he remarked: "Yes, they are both beautiful things."
And when asked if he could render silence in music, he replied
without the least hesitation, "I should need at least three
military bands."

That Cézanne believed in Cabaner's talent is evidenced
by a letter written to introduce the musician to his friend

Roux.[1] But those who were not prejudiced by friendship had a different tale to tell. At best Cézanne considered music an inferior art, with the exception of the melancholy notes of the hurdy-gurdy, which charmed his sentimental soul. He admired its precision. "That *means* something," he would say.

Cabaner was not the only one who lavished encouragement upon Cézanne. The painter had found a great "moral support" in Monsieur Choquet, an unassuming employee of the government, an art collector in his spare moments. Choquet came to know Cézanne through the good offices of Renoir. A passionate admirer of the art of Delacroix, Monsieur Choquet had found his favorite master again in Renoir. Cordial relations grew up between them. Renoir eagerly told Monsieur Choquet about Cézanne and even brought him to the point of buying a study of *Bathers*. Then Choquet's troubles began; how was he going to introduce the little canvas into his home, without incurring his wife's displeasure, which the collector dreaded above all else. Finally he agreed with Renoir that the latter should bring the picture to his house, simply under the pretext of showing it to him, and, as he departed, "forget" to take it with him, so that Madame Choquet might have time to get used to it.

Renoir arrived with the little canvas. The stage was set.

[1] *My dear compatriot:*

Although our friendly relations may not have been very regular in the sense that I have not very often knocked at your hospitable door, nevertheless I do not hesitate to address myself to you. I hope you will be willing to disassociate the impressionist painter, the minor part of my personality, from the man, and remember only the friend. So it is not the author of *l'Ombre et la Proie* that I am appealing to, but the Aquasixtain born under the same sun that shone when I first saw the light of day, and I take the liberty of introducing to you my eminent friend, the musician Cabaner. I beg you to look favorably upon his request; I myself shall come to see you again in the event that the door of the Salon should be opened to me.

I beg you to accept, in the hope that my request will be well received, my thanks and my sympathetic friendship.

P. CÉZANNE.

"Oh! what an odd picture," cried Monsieur Choquet, raising his voice a little in order to attract his wife's attention. Then, calling her to him:

"Marie, come look at the little painting that Renoir has brought to show me!"

Madame Choquet offered some *compliment de circonstance,* and Renoir "forgot" the picture when he departed. When Madame Choquet had begun to tolerate the *Bathers* for her husband's sake, Monsieur Choquet asked Renoir to bring Cézanne to see him. The latter, always careless about his personal appearance, arrived wearing an old cap borrowed from Guillaumin; but his reception was none the less cordial. Cézanne's first words were: "Renoir has told me that you admire Delacroix."

"I adore him. Let us look over my Delacroix together."

They began with the pictures on the walls. The cabinet where the watercolors were kept protected from the light was subsequently emptied. After the furniture had been covered, the rest were laid on the floor, and Monsieur Choquet and Cézanne went down on their knees to look at them.

Choquet's admiration for Cézanne's art increased quite as rapidly as his esteem for the man, who soon became a frequent visitor at the house. Monsieur Choquet never missed an opportunity to eulogize Cézanne. You could not talk to him about painting but that he would fling these two words at you: "And Cézanne?" He never succeeded, however, in persuading any one to buy a single canvas; he was quite content if he could merely get a hearing when he began to talk about "his painter."

One day, however, he came to Renoir's studio wreathed in smiles. He had persuaded Monsieur B., a mutual friend, and one of the first buyers of Impressionism, to accept as a present a little study by Cézanne. "I am not asking you to

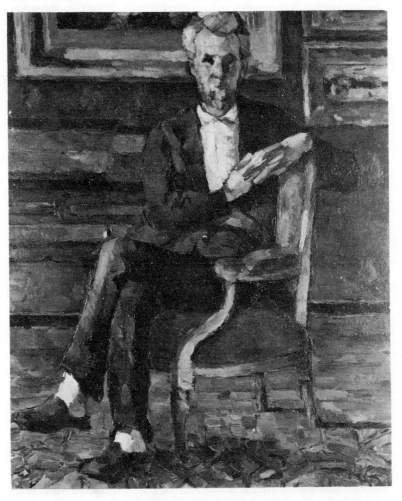

Portrait of Victor Choquet (The Columbus Gallery of Fine Arts, Ohio; Howald Collection).

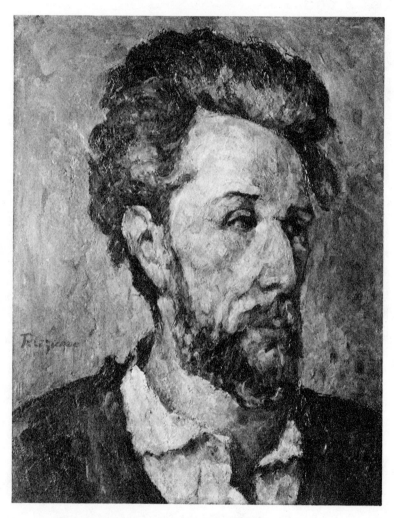

Portrait of Victor Choquet (Private Collection).

hang it in your house," said Choquet, timidly, offering his little gift. . . .

"Oh, I should hope not," agreed Monsieur B., "what an example to set my daughter, who is studying drawing!"

"It will give me so much pleasure," continued Monsieur Choquet, "if you will just allow me to look at these *Apples* from time to time. All you have to do is to put this bit of canvas in the drawer here. . . ."

Inasmuch as there was no expense attached to this, Monsieur B. agreed willingly enough. Some years later, when Cézannes increased in price, he found the little picture lying forgotten in the bottom of the drawer. He took it at once to a dealer. "If that old fool Choquet were only alive today," he said rubbing his hands, "wouldn't he be happy to know that they pay real money for this stuff nowadays!"

Cézanne painted several portraits of Monsieur Choquet. One of them, dated 1877, representing his model seated in an armchair, has for long owed its exceptional notoriety to the fact that it is usually taken for a portrait of Henri Rochefort. *Bathers Resting* [2] belongs to this same period. Cabaner had remarked that there were parts of this picture which were "quite successful"; whereupon Cézanne immediately made him a present of it.

After 1877 Cézanne did not exhibit again with the Impressionist group. From now on the only thing that counted with him was the Salon des Artistes Francais. When one of his friends had a canvas hung in the Salon, he said ironically, "It seems you have talent after all." But none the less it was his lifelong ambition to break down those doors which remained so persistently closed to him. It would be a "kick in the rump" for the Institute, as he put it, if he were to be

[2] The celebrated canvas of the Caillebotte bequest, which was refused by the Luxembourg. See Chap. V.

hung in the same gallery with Bouguereau. But it must be admitted that such language was not calculated to obtain for him the good-will of the "Bouguereau crowd." In fact some of his own friends openly proclaimed him a failure. The defection even extended to Baille, long since come down to earth again, after those lyrical crises when he would wail desperately, "I have lost my ideal!" He concluded by breaking off all relations with his old schoolmate, whom he reproached with not having a sense of reality, and not being a "social power"! Let us hasten to say that Cézanne bore no ill will against his friend Baptistin for deserting him.

Another of his former friends, Duranty, wrote the following account of a visit that he made to Cézanne's studio. He calls Cézanne "Maillobert."

My eyes were assailed by huge canvases hung everywhere, so frightfully colored that I stood petrified. "Ah! Ah!" said Maillobert with a drawling, nasal, hyper-Marseillaise accent. "You are a lover of painting, Monsieur?" Then, pointing to his most gigantic works, he added, "Here are the little scrapings from my palette!"

At this point, I heard a parrot screaming: "Maillobert is a great painter, Maillobert is a great painter!" . . .

"That is my art critic," said the artist, with a disconcerting smile.

.

He observed that I was looking with some curiosity at a row of big druggist's pots set out on the floor, and bearing abbreviated Latin inscriptions: *Jusqui., Aqu., Still., Ferug., Rib., Sulf., Cup.,* and volunteered:

"That, Monsieur, is my paint box. I am going to show 'em that with drugs I can paint beautiful things, while they, with their fine colors, make nothing but drugs!"

.

"You see," Maillobert continued, "one can't paint without temperament" (he pronounced it "temperrammennte").

.

He dipped a spoon into one of the drug pots and withdrew it dripping with green paint. On the easel was a canvas on which a landscape was indicated by a few lines. To this he applied the paint, turning the spoon round and round, until, by a stretch of the imagination you could see a meadow on the canvas. I then observed that the color on his pictures was nearly half an inch thick, and formed miniature valleys and hills like a relief-map.[3] Evidently Maillobert is convinced that a pound of green is greener than an ounce of the same color." [4]

Cézanne was not disheartened, and every year sent two canvases to the Salon. They were consistently refused, until, in 1882, the news came out of a clear sky that one of his entries, a portrait, had just been accepted! Of course he got into the Salon by the back door. His friend Guillemet, who was serving on the jury, and who tried in vain to get Cézanne's canvas accepted on the second vote, had put it through *pour sa charité* for at that time every member of the jury had the privilege of taking into the Salon a canvas by one of his pupils, without any conditions. The catalogue of the Salon of 1882 contains this entry on page 46:

"Cézanne, Paul; pupil of M. Guillemet; Portrait of M. L. A." [5]

Later, in the interests of equality, the Jury was deprived of this autocratic privilege, a regulation which denied Cézanne his only chance of being shown a second time at the

[3] After 1880 Cézanne ceased to paint with a thick impasto. He had discovered, he said, "that painting was not the same thing as sculpture." This did not deter him, however, from painting "thick" again towards the end of his life.

[4] Duranty, *le Pays des Arts*, Charpentier, pp. 316-320.

[5] In spite of every endeavor, I have been absolutely unable to discover either the complete name of the model who posed for this picture, or just which canvas the name is supposed to refer to.

Salon of Bouguereau. But the painter was again to have the satisfaction of being represented in surroundings no less "official," the Universal Exposition of 1889. It is quite true that here again he was accepted through favoritism, or, more accurately, by means of a "deal." The committee had importuned Monsieur Choquet to send them a certain very precious piece of furniture, which they counted on featuring at the exposition. He loaned it as a matter of principle, but he made the formal condition that a canvas of Cézanne's should be exhibited as well. Needless to say the picture was "skyed" so that none but the owner and the painter ever noticed it.

No matter; imagine Cézanne's joy at seeing a picture of his actually *hung* once more! But alas! his happiness was not unalloyed this time because his father was no longer able to share it. In fact Cézanne had had the misfortune of losing his father four years before, in the year 1885;[6] but he consoled himself with the thought that his lamented parent had harbored an unshaken confidence in the ultimate triumph of his son. This exemplary faith was a matter of paternal pride with Monsieur Cézanne: "How could I, Cézanne, have fathered an idiot!" As for the mother, who lived until eight years later, passing away in 1897, if *she* longed to see her son's efforts rewarded it was because she knew how her Paul suffered from being misunderstood; beyond that it made no difference if his work sold or not, as long as "the dear child didn't starve."

In 1890 Cézanne exhibited three canvases at the "Twenty" in Brussels: a *Landscape* then belonging to Monsieur Robert de Bonnières, and today in the museum at Berlin; the *Cottage at Auvers-sur-Oise* from the Choquet collection; and a com-

[6] Cézanne *père* left a large fortune to his son and his two daughters. (*Trans. Note*)

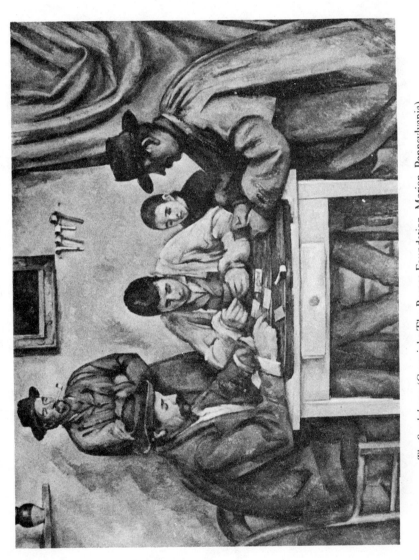

The Cardplayers (Copyright The Barnes Foundation, Merion, Pennsylvania).

Group of Bathers

position of *Bathers*.[7] Subsequently the painter slashed this last canvas with a palette knife, then worked on it again, and finally left it unfinished.

Two years afterwards, in 1892, Cézanne executed one of his most important works, *The Card Players,* after making several preliminary studies for the various figures which appear therein. There exists also a smaller replica of the same subject, in which the young girl who, in the larger canvas, stands near the table watching the game, does not appear.

It was in this same year that I saw Cézanne's pictures for the first time. It was at Tanguy's in Rue Clauzel. Père Tanguy, a color merchant on a small scale, was the benefactor of more than one unrecognized artist. He considered himself something of a "rebel" because he had not been shot down under the Commune by the party of law and order. In reality he was just a good old soul who extended credit to impecunious artists, and took a passionate interest in their work. But he had a marked predilection for those whom he called with respectful emphasis, "the gentlemen of the School": Guillaumin, Cézanne, Van Gogh, Pissarro, and Vignon, to mention only a few. To his way of thinking, being one of the "School" was equivalent to being "modern": which meant that one must banish "tobacco juice"[8] from the palette forever, and paint "thick." He cast a suspicious eye upon anyone who had the audacity to ask for a tube of black. But with good-hearted indulgence, he grudgingly bestowed his respect, after all was said and done, upon the luckless painter who honestly sought to earn his daily bread with ivory black. And if the truth

[7] "Are these pictures calculated to give us any idea whatsoever of the new art?" asks the *Fédération Artistique Belge* (January 26, 1890) in reviewing this exhibition. The reply followed at once: "Art at sword's points with sincerity."

[8] *Jus de chique,* painter slang for thin mediums such as varnish or turpentine. (*Trans. Note*)

were known, Père Tanguy, in common with the very "Philistines" whom he scorned, was convinced at the bottom of his heart that hard work and good behavior were not merely prerequisites, but indispensable elements of success. Accordingly, referring to the author of a picture done with the forbidden "thin mediums," he said candidly. "He's not one of the 'School'; he'll have a hard time arriving. But he'll get there in the end; he never plays the races and he doesn't drink a drop!"

Since it had not yet become the fashion to pay high prices for "horrors," nor as yet even low prices, people seldom went out of their way to go to Rue Clauzel. But when a collector did come to see the Cézannes, Tanguy would conduct him to the painter's studio, to which he kept a key, and allow him to choose whatever he might want from the different piles of canvases, at a standard price of forty francs for the small ones and one hundred for the large. There were also some canvases on which Cézanne had painted several little studies of various subjects. He left it to Tanguy to cut them up. These little sketches were intended for collectors who could afford neither one hundred nor forty francs. So one might have seen Tanguy, scissors in hand, disposing of tiny "motifs," while some poor Mycaenas paid him a louis and marched off with three *Apples* by Cézanne!

When I came to know Tanguy things had changed to some extent. Not that the collectors had become more astute, but Cézanne had taken back his key, and father Tanguy, who had been apprised by Emile Bernard of the superiority of certain works over others, cherished the few Cézannes that he had left as priceless treasures. But, be it said to his credit, he never descended to using the magical phrase "private collection," even if he were ever aware of its fascination over a buyer. Nor did he know how to employ Madame Tanguy's

"personal attachment" to a picture as a pretext to advance the price. But with visions of some day making a big deal which would enable him to be sure of his rent, and to offer unlimited credit—even to painters who were not of the "School"—he locked up his Cézannes securely in his trunk. After his death they were scarcely contested at the Hotel Drouot auction.[9]

[9] Cézanne—*Farm,* height 60 cm., width 73 cm., 145 fr.
 " *Village* " 46 cm., " 55 cm., 175 fr.
 " *Village* " 45 cm., " 54 cm., 215 fr.
 " *The Bridge* " 60 cm., " 73 cm., 170 fr.

(*Gazette de l'hôtel, Drouot,* June 19, 1894.) One Cézanne was not listed in the Gazette; sales under 100 francs are not mentioned.

CHAPTER V

IN 1895 the Government was confronted with the necessity of deciding whether or not it would accept the Caillebotte bequest for the Luxembourg Museum. Among the paintings in this bequest were a few by Cézanne, notably the *Bathers Resting,* formerly given to Cabaner, and after Cabaner's death acquired by Caillebotte for the sum of three hundred francs. It was an enormous price at that time, but when Caillebotte liked a picture, the price meant nothing to him. When Cézanne heard that his *Bathers* was going to the Luxembourg, the ante-chamber of the Louvre, he exclaimed with genuine feeling, "At last I've————on Bouguereau." This remark, bandied from mouth to mouth, was a great success, save in the high places of officialdom where it was considered supremely undignified. But the authorities took their revenge by decreeing that the *Bathers* should not be accepted for the Luxembourg, a decision upon which the Beaux-Arts counted secretly to rid them of the nightmare of the entire Caillebotte collection; for by the terms of the will, it was stipulated that all of the pictures should be accepted, or none at all.

But they had not foreseen the disinterestedness of Caillebotte's heirs. They (the heirs) "respected the condition imposed," but their "esteem for the 'spirit' of the donor" was such that "they did not attach too much importance to the 'letter' of the will." In consequence the administration of the Beaux-Arts felt at liberty to play their game more openly.

Professing a "lack of space," and "taking into consideration the interests of the painters themselves," they rejected eight Monets, three Sisleys, eleven Pissarros, a Manet, and two other Cézannes, a *Flower Piece* and a *Country Scene,* twenty-five canvases in all. In such manner the Caillebotte collection was reduced by nearly a half. Alas! no triumphal invasion of the Luxembourg for the Impressionists; the friends of "honest painting" were adamant. Why! hadn't some of the professors at the Ecole des Beaux-Arts talked of resigning?

The heat and the clamor of this wrangle merely made me all the more determined to organize in Paris a general exhibition of Cézanne's work, a resolve which dated from some time back. Pissarro, who possessed some of the master's most beautiful canvases, immediately offered to lend them to me, with the sole reservation that I should obtain the consent of the artist.

Alas! the task was to find the artist! I finally discovered that he had been seen painting in the Forest of Fontaine-bleau. I searched its every nook and cranny. At Avon I was told that "Monsieur Cézanne had been there, yes indeed, but it's three months now since he went away!" Where? They had no idea. To my query: "Did Cézanne have much to do with the people of the neighborhood?" they merely replied that the painter had procured a small package at a stationery store once, in Fontainebleau. I visited all the stationers in the city, and at last found the one in question. From him I learned that Cézanne had actually had a studio at Fontaine-bleau. I thought my quest was ended, but no, the owner of the studio told me that his tenant had returned to Paris, and that he could not remember the address. The only fact that had stuck in his memory was that the street where Cézanne now lived bore the name of a saint coupled with the

name of an animal. I went through the list of the Paris streets with a fine-toothed comb, but without result. At last I accidentally hit upon a street which suggested the desired conjunction of saint and beast. One of my friends lived in Rue des Jardins; I happened to remember that that street was also known as Rue des Jardins-Saint-Paul, on account of its proximity to the church of that name. Not far from there, Rue des Lions joined it at right angles. I began to have hope. There, in all probability, was the name of the animal, and with it was associated, in popular parlance, the name of a saint, patron of a nearby church. Therefore I resolved to inquire from door to door the entire length of "Rue des Lions-Saint-Paul"; and lo! at Number 2, in response to my question, I was pleasantly surprised to hear; "Monsieur Cézanne? Yes, he lives here."

But he had returned to Aix! The fates had conspired against me. His son was at home, however, and promised to write to him that very day.

Some weeks later he brought me Cézanne's consent. Renoir happened to be with me at the time. He told young Paul Cézanne in no uncertain terms how timely he thought such an exhibition would be. He had always deplored the obscurity to which certain of Cézanne's best friends, at least those who declared themselves such, had relegated him.

Pissarro, I regret to add, could not make up his mind at the last moment to part with his pictures. But by way of compensation I secured nearly one hundred and fifty canvases from Cézanne himself. He sent them rolled up to spare them as much as possible, because he decided that in transportation the stretchers took up too much space.

All that was left to be done was to organize my exhibition. I was fortunate in finding some narrow white moulding at two cents a yard which an apprentice joiner let me

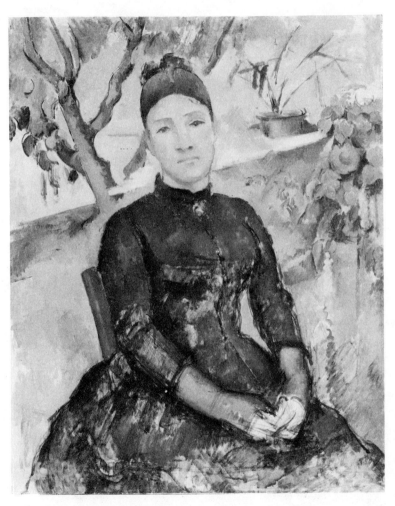

Mme. Cézanne in the Conservatory (The Metropolitan Museum of Art, New York; Bequest of Stephen C. Clark, 1960).

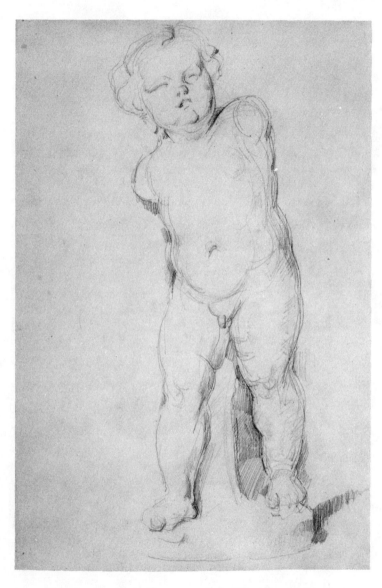

L'Amour de Puget (Courtesy of the Brooklyn Museum, New York).

have very cheaply. At last I was in a position to announce, through the good offices of some journalist friends, that an exhibition of Cézanne's work would open in December, 1895, at 39 Rue Laffitte.

Following are the most important canvases: *Leda and the Swan* 1868; *Self-Portrait* 1880; *The Abandoned House* 1887; *Study of Bathers* 1887; *The Forest of Chantilly* 1888; *The Great Pine-Tree* 1887; *Portrait of Madame Cézanne in the Conservatory* 1891; *The Banks of the Marne* 1888; *Self-Portrait* 1890; *Young Girl with a Doll* 1894; *Underbrush* 1894; *Madame Cézanne with the Green Hat* 1888; *Bather before a Tent* 1878; *Portrait of M. G.* 1880; *The Al Fresco Luncheon* 1878; *The Basket of Apples* 1885; *Estaque* 1883; *The Jas de Bouffan* 1885; *Auvers* 1880; *Gardanne* 1886; *The Fight* 1885; *Portrait of Madame Cézanne* 1877.

The advent of these masterpieces, or of these monstrosities, whichever you prefer, created the most profound excitement among the enlightened collectors and eclectics who, in search of a *Fabiola* by Henner, a *Lansquenet* by Roybet, a *Venetian Scene* by Zeim, a *Horseman* by Détaille, or a *Bouquet of Flowers* by Madeleine Lemaire, came and went every day in front of the shop windows in Rue Laffitte. I had placed in the window the famous *Bathers* of the Caillebotte collection, *Leda and the Swan,* and another study of nudes. It was adjudged an outrage to art—and for some the outrage was aggravated by a violation of their sense of decency. Even my maid, when she saw the fun people made of them, could not refrain from protesting: "I'm afraid that Monsieur is putting himself in a wrong light with all those collector gentlemen, with that picture of naked men in the window!"

But an old inhabitant of Rue Laffitte made less mournful prognostications: "People don't buy the Impressionists yet

because they are ugly; but you'll see, they'll come 'round to buying them no matter how ugly they are; perhaps they'll even hunt them down just because they *are* ugly, on the theory that that very quality will guarantee big prices in the future."

The *Journal des Artistes* sounded the keynote of the criticisms of that year. It trusted that its charming readers would not have heart failure when they saw the "nightmare of these atrocities in oil which even eclipse the legally authorized effronteries." [1] Happily they, the charming readers, belong to a sex which is capable of anything (the *Journal des Artistes* is still speaking); but could even the bravest of the brave pass 39 Rue Laffitte without discomfort?

Atrocious painting, and easy into the bargain: such was the conclusion arrived at by a little telegraph boy and an apprentice pastry-cook who came into my shop together. I mechanically offered my hand to the former, and told the latter, in spite of the tempting aroma that the bakery basket gave off, that he must have made some mistake. But they both assured me with one voice that they came to see the exhibition because there was a sign over the door reading "Admission Free." There was nothing to say to that. After a profound examination of the pictures, the telegraph boy said to his comrade, "Well, well; I suppose the painters can take life easy now that *that's* the stuff that sells." "Ye-e-es," replied the young pastry cook dubiously, "but they must get out of practice awful quick that way."

Another day I heard screams through the door. A young woman was struggling to break away from a man who held her with a grip like steel before a picture of *Bathers*. I caught this bit of dialogue: "How *could* you upset me like this? And I once took a prize in drawing, too!" Then the voice of the man: "That will teach you to be more respectful of me

[1] *Journal des Artistes*, December 1, 1895. *Un comble.*

from now on." Apparently the husband was compelling his
wife to look at the Cézannes by way of punishment.

Still the great majority contented themselves with crying
scandal, without believing themselves "sold" in the proper
sense of the work; the artists, on the other hand, felt their
interests wronged, and, what is worse, were touched in that
tender spot, their dignity. Taking it for granted that the
Cézannes were selling for their weight in gold, they would
say, with what they judged, simply, legitimate resentment:
"Why don't they buy *my* work?" The celebrated painter
Quost was a case in point. He himself and certain of his
colleagues had surnamed him "the Corot of the Flower." He
burst in upon me one day, and demanded with an air which
he intended should appear aggressive: "What is that thing in
the window supposed to represent?" I replied that being
neither a painter, nor an art critic, nor even a collector, I
could not give any official answer to his question, but that in
the catalogue it bore the designation *Flowers.*

"Flowers!" he gasped, "flowers!! Has your painter ever
even looked at a flower? How many years, monsieur, have I,
who stand before you now, spent in intimate communion with
the flower. You know what my friends call me, Monsieur?
The Corot of the Flower!" And, rolling his eyes up towards
the ceiling, he apostrophized: "Oh! corollas, stamens, calyces.
stems, pistils, stigmas, pollen, how many times have I drawn
thee and painted thee! More than three thousand studies
of detail, monsieur, before daring to attack the humblest
flower of the field! And I can't sell them." Then, with a
smile: "But your Cézanne painted that from paper flowers,
didn't he?" I had to admit that, indeed, after having tried
paper flowers, because they faded less quickly than the nat-
ural article, Cézanne had finally copied this bouquet from
an engraving, to obtain greater dependability of pose.

Another painter stopped before my window with his wife. "Just look at the stuff that sells nowadays!" wailed the spouse, provoked. "You must be heartless to persevere in your wonderful art, while your wife and children are dying of starvation!"

"But my *honor,* woman! Would you want me, at my age, to shame myself, and blush before my offspring? No, no, I shall not leave you a tarnished name!"

Happily, this bit of dialogue was not overheard by my first purchaser since the opening of the exhibition. It was a blind collector, blind from birth as he told me later; but, being the son and the grandson of artists, he had an inborn taste for things of art. He arrived with uncertain step, guided by a servant, just as the man who was "conquered of life" moved on. To compensate for his lack of sight, he had engaged a valet who had done a little painting. Thus the valet explained pictures to his master in terms of "shop," to the great delight of the blind man. The collector confided to me that by inheritance as well as by personal taste, he was of the old school—of the days when "they used to draw" (and so saying he made the gesture with his thumb of drawing in the air), and that, if he went so far as to buy a Cézanne, although Cézanne's conception of art and his own were two quite different things, it would only be by way of homage to Zola who had honored Cézanne with his friendship. "For I am in favor of honest vision, too," he said.

He asked me to let him "see" some of the older pictures belonging to a period when Cézanne "took more pains with his work, and did not bother about selling it." He took a canvas in his hands and let his fingers wander over the surface, guided by his assistant who described in detail the parts that he touched as he came to them. After rejecting a certain number of canvases, one among them because there was "not

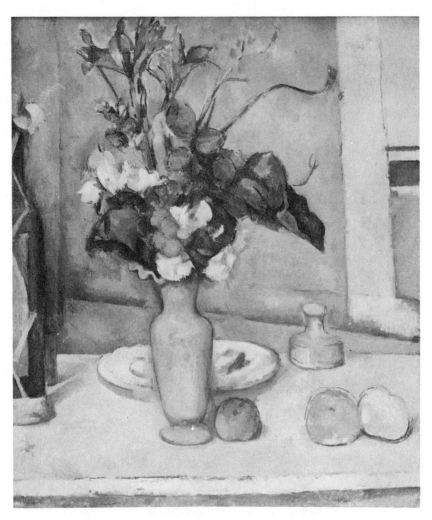

The Blue Vase (Louvre, Paris; photograph from the National Museums).

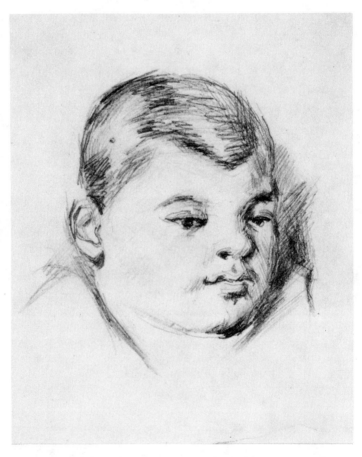

Portrait of His Son Paul (Kunstmuseum, Basel).

enough sky," he chose one painted with a palette knife. "I'm prejudiced in favor of drawing," he said to me, "but I don't mind a certain boldness of execution." He also declared that, since he wanted a water piece, he was happy to have found a canvas painted lengthwise. "The water seems to spread out better that way," he said.

While the blind man was making his choice, a man and a woman were standing in front of the window. When they saw him go away with a picture under his arm, they rushed into the shop. I heard the woman whisper, "Oh, I'm *so* happy, they're selling them."

"That's *just* the way our son paints," she said to me without further ado. "Monsieur Cormon, his professor, threatens to send him home if he *would* paint without drawing first. Don't you think he's on the right track to make good money if Cézanne's pictures sell?" I was compelled to reply that Cézanne, now fifty-five years old, had not made enough with his paintings after thirty-five years of unremitting toil, even to pay for his brushes and colors. The mother was prostrated. The husband enjoyed a modest triumph but contented himself with saying gently, "You see, dear child, without drawing. . . ."

Day after day, the most extraordinary persons dropped in to see the exhibition. There was one man who, after buying one of the most beautiful canvases in the shop, turned around and asked me, "Why are these so-called 'good' pictures always so horrible to look at?" This began to look dangerous, and I tried to change the subject, but my customer reassured me that he was not buying the Cézanne because he liked it, oh Lord no, but to make a big deal later on. I could not forbear from complimenting him upon his foresight, and urged him to go into the speculation on a larger scale; but he decided that it would not be wise to "put all his eggs in the

same basket." Our conversation was brought to an end by the entrance of two new arrivals. They looked first at the pictures and then at each other.

"Drawing doesn't count any more?" said one with a belligerent scowl.

The other replied calmly: "Have patience. Time has no respect for work that took no time to do."

It was Gérôme and Gabriel Ferrier.

I recollect a visit that I made in the interests of my exhibition to a certain Monsieur N., an artist, to whom Cézanne had given some of his canvases.

"Are you a connoisseur or a buyer?" he asked, in response to my request to see his Cézanne.

"A buyer from necessity," I replied.

"Then I will show you some of my own pictures. How do you like these two little still-lifes?"

"Very fine. But the Cézannes?"

"Cézanne is a friend of mine and I never allow anyone to make fun of my friends if I can help it. Every connoisseur and painter that saw those pictures of his said: 'Who is the ass that painted those things?' so I felt I ought to destroy them, so as to be sure that nobody would ever make fun of him again, even after his death."

"You dared to destroy those pictures?"

"Oh, no! It would have been a shame to waste such good canvas. I painted over them."

I tried to make my escape, not wanting to hear any more, but the wife of this over-zealous friend detained me and said with an engaging smile: "You will never find better fruit or fish than my husband paints. We buy our models at the very best stores."

I hasten to say that there were others among Cézanne's friends who treated his gifts with more respect. Such a one

was Monsieur D., who, professing very advanced political ideas, accepted the canvases that Cézanne gave him, although he thought their style intolerable, because their "anarchistic" tendencies went straight to his heart! When I offered to buy his Cézanne, he exulted; the dissemination abroad of these "outlandish" pictures gratified his revolutionary soul.

Another memory of that exhibition is my skirmish with the painter Z. Inasmuch as he spoke glowingly of Cézanne's gifts of color, I concluded that it would be agreeable to him to offer a little study of *Bathers* in exchange for one of his own works. He looked at me aghast. "Are you unaware that I have been proposed by the Salon for the third medal?" Judging from the prices that the medallist's pictures bring today, I doubt if now, even by selling his whole studio, he could scrape together enough to pay for the little picture that he treated with such contempt.

A still more typical slight was inflicted on the painter himself. Pissarro had begged one of his friends who was going to pass through Aix to say "how do you do" to Cézanne. Monsieur S. went to the Jas de Bouffan where he received a most cordial welcome. For politeness' sake he paid the painter several banal compliments, and even went so far as to praise two bouquets of flowers. Cézanne, delighted to find an admirer of his art, begged him to accept them. Monsieur S. would have been glad to side-step the gift, but he was well-bred, and notwithstanding the annoyance of lugging the canvases about with him on his travels (and *such* canvases!), he accepted them because he would not have hurt Pissarro's feelings for the world.

Several of those who were the most solicitous for the success of the exhibition had persuaded me to take the nudes out of the window, calling my attention to the fact that the

public was not yet ready for them, and that such a display was calculated to discourage the very best of intentions. I finally yielded, a little against my will, and put the nudes inside face to the wall; but a visitor, in turning the pictures around, discovered the *Leda with the Swan,* and purchased it on the spot. Thus the first composition of nudes sold during the exhibition was acquired by Monsieur Auguste Pellerin.

A no less discriminating purchaser was King Milan of Serbia. He had bought from me some time previous a large composition by de Groux, representing a "Slaughter of the Mighty of the World." The "slaughter" included a large share of kings and was entitled, *Death to the Cows.* King Milan assured me that he was familiar with the ruminant of today, alas! become quite aphthous. He knew also the meaning of the expression *manger de la vache enragée.*[2] Lastly, he was aware of the fact that the word was applied to girls who had ceased to be pleasing, and to police sergeants; but it was the first time that he had ever seen it used to designate a king. "Very curious, indeed," he said. "I'll buy the picture."

Some time afterwards he brought the thing back. "I haven't grown tired of my picture of dead cows," he said, "but, although in the future it is highly improbable that the people will abandon themselves to a carnage of kings, it is not, perhaps, quite convenient for me to keep the picture in my possession, out of consideration for my fellow-rulers."

Monsieur de Camondo, who happened to be present, and who at this time was already flirting with Impressionism, if I dare so to express myself, advised him to take in place of the de Groux, some water colors by Cézanne. King Milan, dazzled for the moment by the reputation that Monsieur de Camondo then enjoyed as a connoisseur, consented to take the Cézanne. But His Majesty came back to his senses just

[2] *Manger de la vache enragée*—to endure hardships. (*Trans. Note*)

as he was departing, and called back: "Why don't you tell
your Cézanne to paint pretty girls instead?"

On the last day of the exhibition a stranger entered and
examined each picture with the air of a connoisseur. I
thought I had scented a purchaser. Not he! When at last
he broke his silence, he uttered these solemn words. "Un-
happy man, he is not aware that the great Lucretius has
said: *Ex nihilo nihil, in nihilum nil posse reverti!*" He was
evidently only one of those "teachers" of whom Cézanne
loved to say: "They have no guts!" I asked him quite at ran-
dom if he knew Cézanne. The answer came: *"Homo sum
et nil humani a me alienum puto!* At Aix we teachers asso-
ciate only with each other!"

I had occasion a little while later to meet certain of Cé-
zanne's fellow townsmen; for the day was drawing near
when, after having put the master's painting before Paris
and the Parisians, I was going to discover for myself what
manner of man he really was.

CHAPTER VI

1896

STENDHAL found the journey from Marseilles to Aix abominably ugly. To me it was an enchantment: the tracks of the railroad seemed to run straight through the canvases of Cézanne.

When I first encountered the master, I was hard put to it to suppress a cry of surprise. He was the same man who, two years earlier, had come in to see an exhibition by Forain at my galleries. After this person had examined them all with the greatest care, he turned to me and said, with his hand already on the door knob: "One day at the Louvre, about 1875, I saw a young man copying a Chardin. I stepped closer to look at his work and I said to myself, 'He'll arrive; he's working for form!' It was your Forain."

Cézanne greeted me with outstretched hands. "My son has often spoken of you. Excuse me for a little while, Monsieur Vollard, I am going to rest a moment before dinner. I have just come back from my *motif*. Paul will show you the studio."

The first thing that struck me as I set foot in the studio was a huge picture of a *Peasant* pierced full of holes with a palette knife. Cézanne used to fly into a passion for the most absurd reasons—sometimes for no reason at all—and was wont to vent his anger upon his canvases. One time, for instance, thinking his son looked a little jaded, he immediately imagined that the boy had "slept out," woe to the canvas

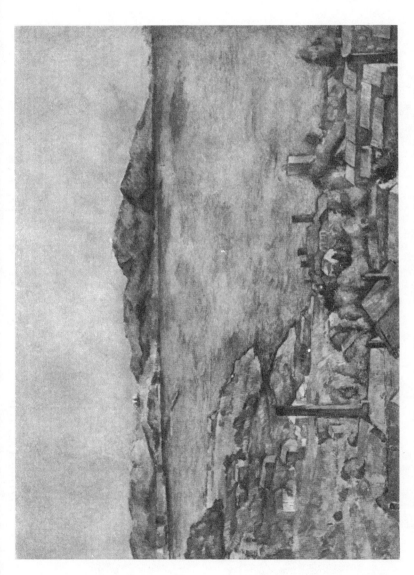

The Gulf of Marseilles Seen from l'Estaque (The Metropolitan Museum of Art, New York, Bequest of Mrs. H. O. Havemeyer, 1929; the H. O. Havemeyer Collection).

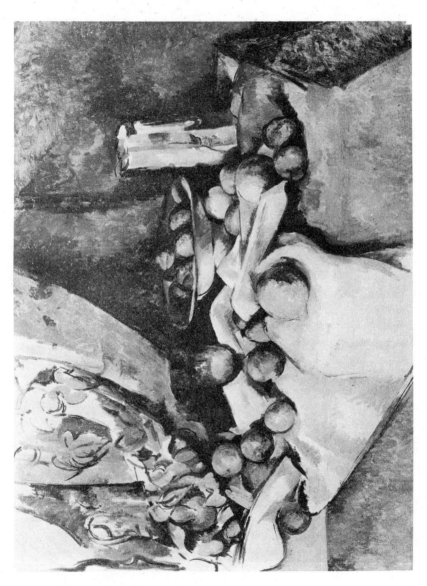

Still Life with Apples (The Museum of Modern Art, New York; Lillie P. Bliss Collection).

which happened to be nearest at hand! I may add that the
world has young Paul to blame for the destruction of more
than one Cézanne. As a child he used to poke holes in his
father's canvases to the great delight of the fond parent.
"Look, my son has opened up the windows and chimneys!" he
would say. *"He* knows it's a house, the little rascal!"

Cézanne's household held the painter in such respect that,
when he left a mangled canvas in the garden or on the ash
heap, they saw to it that it was put in the fire. An exception
to the rule was a certain still-life. Cézanne had tossed it out
of the window, but it had caught in the branches of a cherry-
tree, and had hung there a long time. Inasmuch as they had
seen Cézanne armed with a long pole prowling about the
tree, they decided that he intended to recover the canvas, and
consequently they left it severely alone. I was present when
the canvas was rescued. We were walking in the garden, Cé-
zanne, young Paul, and I. The painter, who was a few paces
in advance, his head slightly bent, turned around suddenly
and said to the young man: "Son, we must get down the
Apples; I think I'll work on that study some more."

Cézanne passionately loved the things that belong to art,
but he wanted them in the museums, their natural abode.
Consequently his studio contained none of the rare pictures
or precious furniture, none, in fact, of the artistic plunder
of which most artists are so fond. On the floor lay a big box
stuffed full of water color tubes; some apples, still "posing"
on a plate, were in the last stage of decay; near the window
hung a curtain, which always served as a background for
figure studies or still-lifes; lastly, there were pinned on the
walls engravings and photographs, both good and bad, chiefly
bad, representing *The Shepherds of Arcadia* by Poussin,
The Living Bearing the Dead by Lucas Signorelli, several
Delacroix, *The Burial at Ornans* by Courbet; *The Assump-*

tion by Rubens, a *Love* by Puget, some Forains, *Psyche* by Prud'homme, and even the *Roman Orgy* of Couture.

At dinner, to which I had been invited, Cézanne was in high spirits. What impressed me especially was his extreme politeness and courtesy when asking the slightest favor. His favorite words seemed to be "Excuse me!" but notwithstanding his spirit of courtesy, I guarded my every word with the utmost care, for I was apprehensive lest I should call forth Cézanne's anger, which was always ready to burst out at the slightest provocation. All my precautions, however, did not prevent me from making the much dreaded "break." We were talking of Gustave Moreau. I said, "It seems that he is an excellent teacher." When I began to speak, Cézanne was in the act of lifting his wine to his lips; he stopped, holding it in mid air, and cupped the other hand behind his ear, being a little hard of hearing. He got the full force of the word "teacher." Its effect was like an electric shock.

"Teacher!" he shouted, setting down his glass so hard that it broke; "they're all god-damned old women, asses, all of them! They have no guts!"

I was floored. Cézanne himself was speechless for a time after the ruinous outburst he had been guilty of. Then he broke into a nervous laugh, and, returning to the subject of Gustave Moreau, went on: "If that distinguished æsthete paints nothing but rubbish, it is because his dreams of art are suggested not by the inspiration of Nature, but by what he has seen in the museums, and still more by a philosophical cast of mind derived from too close an acquaintance with the masters whom he admires. I should like to have that good man under my wing, to point out to him the doctrine of a development of art by contact with Nature. It's so sane, so comforting, the only just conception of art. The main thing, Monsieur Vollard, is to get away from the école—from all

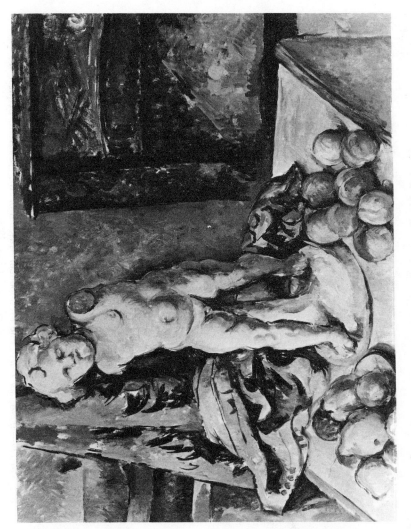

Still Life (Nationalmuseum, Stockholm).

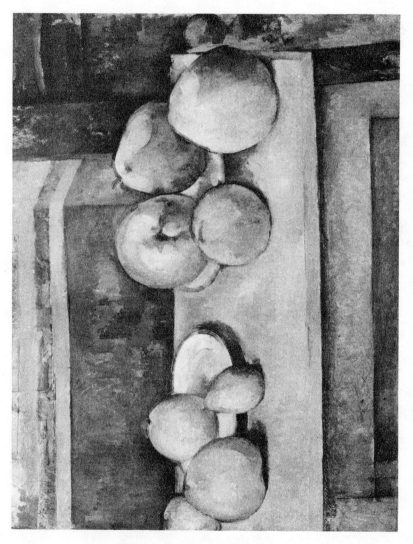

Still Life—Apples and Pears (The Metropolitan Museum of Art, New York; Bequest of Stephen C. Clark, 1960).

the schools. Pissarro had the right idea; but he went a little too far when he said that they ought to burn all the necropolises of Art."

A moment later the name of a young man from Aix was mentioned, a fellow who had just become a Bachelor of Sciences at Paris. Accordingly, happy to have found something to talk about, the extreme banality of which might escape all criticism, and also seeking to honor the city, I offered the suggestion that Aix should be proud to have given to the world a future savant. But young Paul put his fingers to his lips. I did not seek to elaborate the idea at the time, but, upon leaving the table, I asked for an explanation of the gesture. "My father," the young man said, "has a horror of savants; he puts them in the same class with teachers." Happily we saw not a single teacher or savant that evening, so that it was all plain sailing; during the remainder of the repast, we continued to talk painting and literature. Cézanne aired his enthusiasm for Courbet—"setting aside the fact that he is a little heavy as to expression." I mentioned Verlaine; by way of reply he stood up and recited these lines:

> Rappelez-vous l'objet que nous vîmes, mon âme,
> Ce beau matin d'été si doux:
> Au détour d'un sentier, une charogne infâme,
> Sur un lit semé de cailloux,
>
> Les jambes en l'air, comme une femme lubrique,
> Brûlante et suant les poisons,
> Ouvrait d'une façon nonchalante et cynique
> Son ventre plein d'exhalaisons.

When he had finished, I brought back the name of Verlaine into the conversation. . . . Cézanne interrupted me: "Baudelaire——there's a writer for you. His *Art Romantique*

is amazing and he makes no mistakes in the artists that he appreciates."

Cézanne could not endure either Van Gogh or Gauguin. Emile Bernard relates that, when Van Gogh showed Cézanne one of his canvases and asked him what he thought of it, Cézanne replied,

"You positively paint like a madman." [1]

And as for Gauguin, he accused him of having tried to "rob him of his thunder." So I took occasion to tell Cézanne in this connection how much respect and admiration Gauguin had for him; but Cézanne had already forgotten about the painter of Tahiti. "You understand, Monsieur Vollard," he said seeking to enlist my sympathies in his own cause, "I have a little thunder, but I can't seem to express it. I'm like a man who has a piece of gold, and can't make use of it."

To divert the master's train of thought, I informed him that a collector had just acquired three of his pictures in one purchase at my gallery.

"Was he a Frenchman?" inquired Cézanne.

"A foreigner, a Hollander."

"They have some fine museums there!" he mused.

Anxious to display my enthusiasms in art, I began to praise the *Night Watch*. Cézanne interrupted me.

"I know of nothing more ridiculous than all those people who crowd about the *Night Watch* and sigh with ecstasy. They would be the very first to vomit on it if Rembrandts should begin to go down in price. . . . Why, with that mob around it, if I only had to blow my nose, I'd have to leave the room. You know, Monsieur Vollard, the grandiose (I don't say it in bad part) grows tiresome after a while. There are mountains like that; when you stand before them you shout, 'Nom de Dieu. . . .' But for every day a simple little

[1] *Mercure de France,* Dec. 16, 1908. P. 607.

hill does well enough. Listen, Monsieur Vollard, if the *Raft of the Medusa* hung in my bedroom, it would make me sick." Then suddenly: "Ah! when will I see a picture of mine in a museum?" It just so happened that Monsieur de Tschudi, director of the National Gallery in Berlin, was desirous of acquiring a picture of the Jas de Bouffan. I acquainted Cézanne with the fact and deplored the interdiction of the German emperor against the Impressionists. "He's right," cried Cézanne, "everybody's going crazy over the Impressionists; what art needs is a Poussin made over according to nature. There you have it in a nutshell!" Then, leaning towards me with a confidential air, but with the loud voice habitual with people who are hard of hearing: "William is all to the good!" I soon had occasion to observe, however, that the agreement between Cézanne and the Emperor of Germany was not quite complete. I mentioned the name of Kaulbach, of whom, we are told, the Emperor loved to say, "We too have our Delaroche." Cézanne foamed at the mouth: "I don't have anything to do with emasculated art!"

We talked of Corot. Cézanne, his voice choked with laughter, said: "Emile used to say that he might have enjoyed Corot to the utmost if he had peopled his forests with peasants instead of nymphs." Then, rising, he brandished his fist at an imaginary Zola: "The god-damned idiot." His anger suddenly subsided, but with the traces of emotion still in his voice, he said, "Excuse me, I love Zola so much!"

As for Puvis de Chavannes, I never had to ask Cézanne what he thought about him. Renoir had told me that one day at the studio of a mutual friend, when the conversation had turned to Puvis, and when every one was paying homage to *The Poor Fisherman,* Cézanne, who appeared to be asleep on the sofa, half raised himself and remarked, "Yes, it's not

bad imitation." [2] I must add that at my Cézanne exhibition, Puvis de Chavannes, after having attentively examined the pictures, departed with a mere shrug of the shoulders.

Nor did Cézanne relish Whistler nor Fantin-Latour, both of whom paid him back in the same coin. Whistler, who had seen at my shop the portrait of Cézanne's sister, which so strangely resembles a Greco, said in all seriousness: "If a six-year-old child had drawn that on his slate, his mother, if she were a good mother, would have whipped him."

Fantin-Latour pronounced a like sentence. At Fantin's studio, I had encountered a commissioner of the Louvre of whom I requested authority to take to the museum one or two Cézannes, in order to compare them with the Chardins and the Rembrandts. Ordinarily Fantin-Latour was kindness itself, and never voiced, especially about painters, any but the most innocuous truths; but at the mere thought of a Cézanne carried through the halls of the Louvre, he burst out: "Don't you dare to treat the Louvre lightly in my presence!"

[2] By "imitation" Cézanne meant stupid realism. (*Trans. Note*)

CHAPTER VII

AIX AND ITS PEOPLE

CÉZANNE loved his native city passionately. Each house, each street brought back memories of his childhood. Nevertheless he considered the people of Aix "barbarians." They in turn judged him quite as severely. But their contempt began to diminish appreciably from the very day that Cézanne's pictures began to sell.

I had imagined that at Aix "Cézannes" grew on every bush. I was told that for long Cézanne had offered his canvases to any comer, and used even to abandon them in the fields, like the water-color of *Bathers* that Renoir discovered while walking one day among the rocks at Estaque. My expectations were not fulfilled; the people of Aix were not the kind to be deceived by such "daubs."

But behold! an individual arrives at my hotel with something wrapped up in a cloth. "I've got one of them," he said without further ado; "as long as they want 'em in Paris, and they're going big, I want to be in the swim." He undoes the package and shows me a Cézanne. "Not less than one hundred and fifty francs," he cries gleefully, slapping himself smartly on the thigh, the better to assert his claim and at the same time to bolster up his courage. When I have counted out the money for him, he remarks, "Cézanne thought it was a pretty good joke when he made me a present of that! But the laugh is on him now!" After he has given full rein to his joy he continues, "Come with me!" I follow him to a house. There, on the landing, which at Aix does double duty as

hallway and storeroom, some magnificent Cézannes rub elbows with other articles of the utmost disparity: a bird cage, a cracked chamber pot, a syringe broken beyond repair. (It is a fact that the people of the Midi are loath to throw away or destroy anything whatever that may once have belonged to them.) The door is ajar, but fastened with an iron chain; my guide knocks. A bolt is drawn. Numerous questions are asked. But there seem still to be misgivings, for I overhear some one put this question to my cicerone: "Just how well do you know this stranger who is with you?" An interminable conference follows; finally they demand a thousand francs for the Cézannes on the landing. I hasten to produce a bank note. Another conventicle between the three natives; they inform me at last that the deal will not be concluded until the note has been verified at the Crédit Lyonnais. The husband takes that mission upon himself; his wife recommends that if the note is declared good, he bring the money back in gold; "it will be safer in case of fire." When the husband returns, the precious metal in his hands, their joy is so great that they give me a piece of string into the bargain to tie up the Cézannes! "It's very good cord," the wife assures me. "We don't give it to all our customers." But another surprise is in store for me. I have scarcely left the doorstep when I am hailed from the window. "Hey! mister artist, you forgot one of them!" And a Cézanne landscape falls at my feet!

I had been told about another man at Aix who possessed some studies by Cézanne. I called on him. Before I had gotten my question fairly out of my mouth he cut me short: "Cézanne? I know him well; I was present when he was born. In regard to the study, I have never had but one, and I sold it, after having practiced for forty years, so that I could retire." We might have talked until Doomsday without understanding each other; the study he was referring to

was his bailiff's "study," or office. I tried to make him understand some other way. "Did Cézanne ever give you anything?" "Ah! poor fellow! he gave me some pictures that he made himself. But I write poetry."

Whereupon the old man took some papers from his pocket, and began to read me several hundred lines of verse, under the alluring but misleading title: *"This is a Sonnet."* While he was struggling to regain his breath, I asked, in order not to lose any time: "Have you never thought of selling your Cézannes?" "I never sell things that have been given to me, even if they are not beautiful."

I took leave of the poet and inquired my way to another house at Aix, the home of a certain Countess R., who, I was told, possessed some Cézannes to which she attached no value. I hoped to secure these canvases, but my proposal of purchase was rejected with scorn. I was not even allowed to see them.

"They're in the granary . . . and I tell you again, that's not art. . . ."

Myself: But, they are worth money, and in case the rats. . . .

The Countess (sharply): Well, let my rats eat up my Cézannes; I'm no shop-keeper!

It was my last attempt. But when it was noised about that "Cézannes were selling in Paris," I was besieged by everybody in the province who painted or had ever tried to paint. I did my best to discourage those who brought me samples of their work by explaining that it was too "well done" to sell in Paris, where the preference did not run to "good painting." They were not in the least downhearted about it; it would be easy enough to paint "topsy-turvy," but they simply objected because, if they worked that way, they would have to "paint to order, and if the fashion at Paris

should change, what would they do with their paintings at Aix, where the people wanted their pictures well done?"

Another Aixois thought that he had discovered the reason for Cézanne's success in Paris. "I get the idea," he said to me. "They buy that stuff in Paris to make sport of us Aix folk." In fact there seems to be a very wide-spread notion in the Midi, and also, I imagine, in the North, that Paris has its gaze fixed on the provinces to find something to laugh about.

The foremost among all these "teasers of the palette" was a woman who kept a drug store, and who, in her leisure moments, lovingly painted little lambs eating their straw in *art nouveau* stables. She boasted that she had received advice and encouragement from Cézanne. I asked the master about his pupil. "Listen Monsieur Vollard. Madame S. asked me to give her some lessons, I said to her, 'Follow my example; force yourself, above all, to develop personality.' She's a hard worker, and, if she persists, she may make an excellent second-rate Rosa Bonheur in twenty years or so. If I were as clever as Madame S., I would have gotten into the Salon long ago."

It was on the strength of similar self-disparagements that many people, to whose interest it was to take him at his own word, put Cézanne down as a failure. Nevertheless, if he offered encouragement to Madame S., it was not to make sport of her. He had too much respect for any one who tried sincerely to develop personality. He failed of finding that sincerity in Signol, or in Debufe, whose *Prisoner of Chillon,* "frightfully well done," hung in the Aix museum. He felt that there was more honesty in the art of Bouguereau. Sometimes in an access of fury against himself induced by his difficulty in "realizing," he would even go so far as to say:

"I wish I were Bouguereau," and then explain at once with, "He developed his personality."

One day Cézanne took me over to his sister Marie's house to show me a study which was "rather successful." But it was the hour of vespers and we found no one at home. Being unable to see the picture, I asked Cézanne if he would take a stroll in the garden. Rarely has a walk been so profitable to my soul. Everywhere were posted prayers entitling one to indulgences, some good for a few days, some for several months, and some, indeed, for whole years.

After the visit to Mlle. Marie, Cézanne and I set out along the Arc River. We were trying to escape the heat; there was not a breath of air stirring. Cézanne said, "I should think that this temperature would be useful only for the expansion of metals and to increase the sale of liquor. Now there is an industry that's taking on respectable proportions here at Aix. . . . I'm sick and tired of the airs put on by the 'intellectuals' in my part of the country; pack of b—s, fools, idiots. . . ."

Myself: But there are exceptions, certainly.

Cézanne: There are exceptions but you never hear about them. Real modesty is always unaware of itself. But I do like Jo. . . ."[1]

Shading his eyes with his hand, Cézanne gazed intently at a certain place along the river. "Wouldn't it be wonderful to paint a nude there? There are innumerable motifs here on the banks of the river; the same spot viewed from a different angle offers a subject of the utmost interest. It is so varied that I think I could keep busy for months without changing my place, simply turning now to the right and now to the left.

[1] The poet Joachim Gasquet.

"Listen Monsieur Vollard, painting certainly means more to me than anything else in the world. I think my mind becomes clearer when I am in the presence of nature. Unfortunately, the realization of my sensations is always a very painful process with me. I can't seem to express the intensity which beats in upon my senses. I haven't at my command the magnificent richness of color which enlivens Nature. Nevertheless, when I think of my awakening color sensations, I regret my advanced age. It is distressing not to be able to set down specimens of my ideas and sensations. Look at that cloud; I should like to be able to paint that! Monet could. He has muscle."

Cézanne rated Claude Monet the highest among contemporary painters. Sometimes, in talking about Impressionism, he would attack the painter of the *Hours* with this favorite sally: "Monet is only an eye." And then he would add directly, "but good Lord what an eye!"

We had returned to the city; Cézanne led me to the church of Saint Sauveur, where he pointed out for my admiration the massive walnut doors. They were embellished with carvings, very delicate in workmanship, executed about the year 1500. In the interior of the church, he also showed me a painting, *The Burning Bush,* which the good people of Aix, he said, attributed to King René. "At all events," he added, "it's not bad imitation in a rude way."

Myself: I have read in Stendhal's *Memoirs of a Tourist* that it was good King René who instituted the Procession of the *Fête-Dieu* at Aix.

Cézanne: Listen, Monsieur Vollard. When my friend Zola and I were very young, we followed that procession many a time.

After we left Saint Sauveur, it was time for Cézanne's

siesta, and he returned home. He advised me to go and hear the music on the *Course*. It is one of the prettiest spots in Aix, with its golden plane trees and its three fountains, the central one playing warm water. I observed, not without surprise, that the statue of King René, the handsomest ornament of the square, was besmeared with black. I mentally charged up this misdeed against the republicans of the city; but I learned before long that it had been done by an enfuriated regionalist who had emptied a bottle of ink on the early sovereign of Provence to punish him for leaving his states unprotected, when he died, from the covetousness of the King of France. I learned at the same time that the old nobility of Aix, protesting against the incorporation of Provence with France, rigorously prohibited all commerce with "foreigners," meaning by that designation anybody born farther away than Avignon!

CHAPTER VIII

M Y relations with Cézanne were not confined to the visit I made to Aix. I saw him again on each of his trips to Paris, and his good-will was such that one day I ventured to ask him to paint my portrait. He consented at once, and arranged a sitting at his studio in Rue Hégésippe-Moreau for the following day.

Upon arriving, I saw a chair in the middle of the studio, arranged on a packing case, which was in turn supported by four rickety legs. I surveyed this platform with misgiving. Cézanne divined my apprehension. "I prepared the model stand with my own hands. Oh, you won't run the least risk of falling, Monsieur Vollard, if you just keep your balance. Anyway, you mustn't budge an inch when you pose!"

Seated at last—and with such care!—I watched myself carefully in order not to make a single false move; in fact I sat absolutely motionless; but my very immobility brought on in the end a drowsiness against which I successfully struggled a long time. At last, however, my head dropped over on my shoulder, the balance was destroyed, and the chair, the packing-case and I all crushed to the floor together! Cézanne pounced upon me. "You wretch! You've spoiled the pose. Do I have to tell you again you must sit like an apple? Does an apple move?" From that day on, I adopted the plan of drinking a cup of black coffee before going for a sitting; as an added precaution, Cézanne would watch me attentively,

and, if he thought he saw signs of fatigue or symptoms of sleep, he had a way of looking at me so significantly that I returned immediately to the pose like an angel—I mean like an apple. An apple never moves!

The sittings began at eight o'clock in the morning and lasted until half past eleven. Upon my arrival, Cézanne would lay aside *Le Pelerin* or *La Croix,* his favorite journals. "They're sensible papers," he would say. "They lean on Rome." It was the time of the war between the English and the Boers; and as Cézanne was always in favor of justice, he usually added: "Do you think the Boers will win?"

The studio in Rue Hégésippe-Moreau was even more simply decorated than the one at Aix. A few copies of Forain's drawings, clipped from the newspapers, formed the basis of the master's Paris collection. Cézanne had left what he called his Veroneses, his Rubens, his Lucas Signorellis, his Delacroix—that is to say the penny reproductions of which I have already spoken—at Aix. One day I told the painter that he could get very fine reproductions at Braun's. His answer was: "Braun sells to the museums." He looked upon a purchase from a purveyor to the museums as regal extravagance.

I can never forgive myself for having insisted on Cézanne's putting some of his own work on the walls of his studio. He pinned up about ten water-colors; but one day when the work was going badly, and after he had fretted and fumed and consigned both himself and the Almighty to the devil, he suddenly opened the stove, and tearing the water-colors from the walls, flung them into the fire. I saw a flicker of flame. The painter took up his palette again, his anger appeased.

When a sitting began, he would look at me his eyes intent and a little hard, his brush poised in the air. Sometimes he

seemed restless. Once I heard him mutter fiercely between his teeth, "That fellow Dominique [1] is damnably good;" then, putting down a stroke, and leaning back to judge the effect; "but he gives me a pain!"

Every afternoon Cézanne would be off to copy in the Louvre or the Trocadéro. Not infrequently he would stop in to see me for a moment about five o'clock, his face radiant, and would say, "Monsieur Vollard, I have good news for you. I'm pretty well satisfied with my work so far; if the weather is 'clear gray' tomorrow, I think the sitting will be a good one!" That was his principal concern when the day was done: what kind of weather would we have tomorrow? Inasmuch as he was in the habit of going to bed very early, he usually woke up in the middle of the night. Haunted by his obsession, he would open the window. When he was satisfied about the weather, he would go and look over the work he had done, candle in hand, before getting back into bed. If he were pleased with his examination, he would wake up his wife so that she might share his satisfaction. And to make amends for disturbing her, he would invite her to play a game of checkers.

But for the sitting to be a real success, it was not enough for Cézanne to be satisfied with his study at the Louvre and for the weather to be "clear gray"; there were other conditions necessary, above all that silence should reign in the "pile driver factory." That was the nickname Cézanne had given to an elevator in the neighborhood. I took care not to tell him that when the noise stopped, it probably meant that the elevator was undergoing repairs; I left him to his hope that the owners would fail in business some day. In fact the noise stopped very often, and he reflected hopefully that the pile drivers stopped when business was not good.

[1] Dominique Ingres.

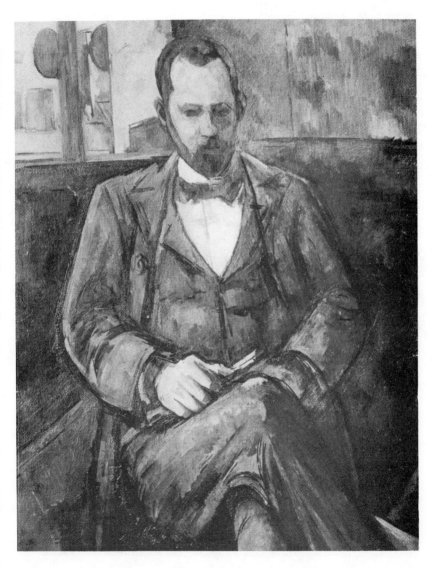

Portrait of Ambroise Vollard (Petit Palais, Paris).

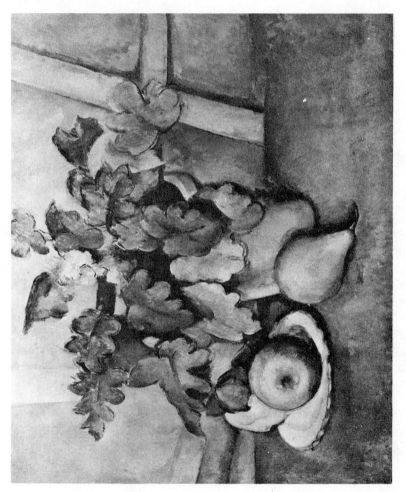

Le Pot de Fleurs (Courtauld Institute Galleries, London).

Another noise that he could not endure was the barking of dogs. There was a dog in the neighborhood which made itself known occasionally—not very loud to be sure. But Cézanne had developed an extremely sharp ear for sounds which were disagreeable to him. One morning when I arrived he greeted me all smiles: "Lépine [2] is a good fellow! He has given an order for all dogs to be put in the pound; it's in *La Croix*." Thanks to this we had several good sittings: the weather continued to be "clear gray," and, by a piece of good fortune, the dog and the pile driver factory never made a sound. But one day, when Cézanne had remarked to me for the thousandth time, "Lépine is a good fellow." a faint "bow-ow-ow" came to our ears. With a start he let his palette fall and cried in a discouraged voice, "The wretch has got loose again!"

Very few people ever had the opportunity to see Cézanne at work, because he could not endure being watched while at his easel. For one who has not seen him paint, it is difficult to imagine how slow and painful his progress was on certain days. In my portrait there are two little spots of canvas on the hand which are not covered. I called Cézanne's attention to them. "If the copy I'm making at the Louvre turns out well," he replied, "perhaps I will be able tomorrow to find the exact tone to cover up those spots. Don't you see, Monsieur Vollard, that if I put something there by guesswork, I might have to paint the whole canvas over starting from that point?" The prospect made me tremble.

During the period that Cézanne was working on my portrait, he was also occupied with a large composition of nudes, begun about 1895, on which he labored almost to the end of his life.

For his groups of nudes, the painter made use of sketches

2 The prefect of police at the time.

from life that he had made some years before in the Atelier
Suisse; beyond that, he resorted to his memories of the mu-
seums.

His ambition was to pose nude models out of doors; but
that was not feasible for many reasons, the most important
being that women, even when clothed, frightened him. The
only exception to this rule was an old servant whom he used
to employ at the Jas de Bouffan, an odd creature with a
craggy countenance about which he used to say admiringly
to Zola: "Look, isn't it handsome? You might almost say
it was a man!"

Imagine my surprise, then when one day he announced
that he wanted to pose a nude female model. I could not help
exclaiming, "What, Monsieur Cézanne, a nude model?"

"Oh Monsieur Vollard, don't worry, I'll get some old
crow!"

He found just the one he wanted, and after doing a
study of the nude, he painted two portraits of the same model
clothed; they remind one of the poor relations that people
Balzac's stories.[3]

Cézanne assured me that he found this "camel" much less
satisfactory as a model than me. "It is becoming very difficult
to work from a female model," he explained. "And besides, I
have to pay very high; the price has gone up to four francs,
twenty sous more than before the war. Oh! if I can only
realize your portrait!" The goal of his ambition was always
the Salon of Bouguereau, until the Louvre should be open
to him. He considered the Louvre the only sanctuary worthy
of his art.

Cézanne used very pliable brushes made of sable or pole-

[3] Among the women who posed for Cézanne, a certain old woman who had for-
merly been a nun's attendant, and who had suffered many misfortunes, might
be mentioned. It was she who posed for the *Woman with a Rosary*.

cat hair; after each touch he washed them in a medium-cup
filled with turpentine. No matter how many brushes he be-
gan with, he used them all during a sitting, and he daubed
himself up to such a degree that once, at Aix, when he was
coming back from his *motif,* the gendarmes asked him for
his identification papers. Cézanne swore that he was a na-
tive; they insisted that they had never seen him before. "Well,
I'm sorry," the painter said, with such an accent that the
police could not have been left with the shadow of a doubt:
a man with an accent like that must have been from Aix!

The solidity of Cézanne's painting is readily explained
when one knows his method of working. Inasmuch as he
did not paint with a thick impasto, but put one layer of paint
as thin as water-color over another, the paint dried instantly;
he never had to fear the internal conflict of the colors which
produces cracks when the upper and the lower layers dry at
different times.

I have already said that Cézanne did not like to be
watched when painting. Renoir, who used to accompany Cé-
zanne on painting trips during his visit to the Jas de Bouffan,
told me just how acute the painter's susceptibilities were. An
old woman was in the habit of installing herself with her
knitting a few paces from where they used to paint. Her
proximity always threw Cézanne into a state of extreme ex-
asperation. One day he could stand it no longer. Seeing her
approach, with his keen and piercing eyes, from a great dis-
tance, he cried: "Here comes the old cow!" and in spite of
all Renoir's efforts to stay him, he packed up his traps and
marched off in a rage.

It is easy to imagine his anger if he were surprised with
brush in hand. One day when he was working in the field
with a young painter named Le Bail, whom he had put in
front of him so that the younger man could not watch him

work, a passer-by who had approached unheard said in a loud voice, "I like the young man's picture better." Cézanne quit at once, furious that any one should have spied on him while he was painting, and very much annoyed at the lout's reflection on his work. Nevertheless he steadfastly believed that the public really knew whether a picture was "well realized" or not. Small wonder that by dint of hearing Cézanne complain of not being able to "realize," that same irreverent public should have found in the end a certain lack of assurance in his work. When some one propounded the idea that this peculiarity was due to a certain irregularity in the painter's visual field, Cézanne seized upon the notion as a fresh excuse for bewailing his inability to realize. Even Huysmans, in his estimate of the painter, gave credence to this myth about a malformation of the eyesight: "An artist with diseased retinæ, who, exasperated by faulty vision, has discovered the prodromes of a new art." [4]

Though Cézanne did not permit me to utter a single word during the sittings, he would talk willingly enough while I was getting ready, and also during the all too short rests that he allowed me. Upon entering one morning I found him grinning from ear to ear. He has discovered in *Le Pelerin* that some shares in the Sosnowice (which he pronounced *Sauce novice*) were being offered to the public. "They'll go bankrupt," he said. "The public isn't fool enough to buy anything with a name like that." Some days later I found him sobered; the stock had gone up. "Too bad, Monsieur Vollard," he said, "they've found some easy marks. Life's frightful, isn't it!" Then, with the sort of self-satisfaction that we feel when others are being made sport of while we ourselves are out of harm's way, he added: "I'm not used to the ways of the world, so I lean on my sister, she leans on her

[4] J. K. Huysmans. *Certains.*

confessor, a Jesuit (they're mighty wise, those people), and
he leans on Rome."

Superficial observers, hearing the great painter complain
of such childish things, and seeing him take everything for
granted without the slightest examination, could not resist
the temptation to turn such naïveté to their profit; but when
Cézanne pulled himself together—and he was forever pull-
ing himself together—he went at them hammer and tongs,
and, once well rid of an intruder, he would pronounce his
favorite phrase: "The wretch, he tried to get his hooks on
me!" Cézanne did not adopt the *laissez-faire* attitude with
any idea of hoodwinking the public. Did he not say of him-
self: "After an event has occurred or an idea has been pro-
pounded, it takes me a long time to perceive clearly its char-
acter and import."

I had been told that Cézanne made a slave of his models.
I proved it to my own satisfaction from sad experience. From
the moment that he put down the first brush stroke until the
end of the sitting, he treated the model like a simple still-
life. He loved to paint portraits. "The goal of all art," he
would say, "is the human face." If he did not paint it more
often, the reason lay in the difficulty of procuring models
who were as tractable as I. Consequently, after painting him-
self and his wife many times, and also a few obliging friends
(at the time that Zola still had faith in Cézanne, the future
novelist consented to pose for the nude), he resorted to paint-
ing apples, and even more frequently flowers—flowers did
not decay: he used paper ones. But "even they, confound
'em! faded in the long run." Therefore, in certain moments
of exasperation against the "contrariness" of things, Cézanne
would even fall back upon the plates in the *Magasin Pit-
toresque,* of which he possessed some bound volumes, or, as

a last resort, upon his sister's fashion magazines! Beyond that there was left but to hope for a clear gray sky, and to dread the barking of dogs, the noise of the pile driver factory, and a few inconveniences of a like nature.

Cézanne had found in me, or so I like to think, his ideal model; hence he made no haste to finish my portrait. "It makes a good study," he would say, setting to work again on some part that was fairly well realized. And he would add, expecting me to be overwhelmed with joy, "You are beginning to learn how to pose."

One day when his bad humor had manifested itself several times during the sitting, and when I had departed after arranging to meet on the morrow, Cézanne suddenly said to his son, "The sky is turning clear gray. When Monsieur Vollard has had time to get a bite to eat, run over to his place and fetch him back."

"But aren't you afraid that Monsieur Vollard will get all tired out?"

"What difference does that make, as long as the weather is good?"

"But if you exhaust him today, perhaps he won't be able to pose tomorrow."

"You're right, son. We must spare the model! You've got the practical view of life."

While pretending to deplore his utterly impractical outlook on life, Cézanne really prided himself upon it privately. One very cold winter, I remember, happening to stop in the middle of a bridge to look at the Seine heavy with ice, I espied someone washing brushes on the bank of the river. It was Cézanne. "The water is frozen at the studio," he shouted. "I hope that doesn't happen here!" and he shot an anxious glance at the ice blocks drifting closer and closer together.

While posing for my portrait, I feared above all the entrance on the scene of the terrible palette-knife. With what care did I guard my merest words! You may be sure I never spoke of painting, nor literature, nor savants, nor teachers; in fact, I usually held my peace, lest Cézanne, who thought of nothing but his work, might misconstrue whatever I said into a desire to contradict, and my portrait might momentarily run the risk of destruction. I thought it most prudent to wait until he spoke to me—but even that had its hidden dangers, as we shall see.

Cézanne had said, "You must go to see the Delacroix in the Choquet collection; they are up for auction." He mentioned in particular a very important water-color of flowers bought by Monsieur Choquet at the Piron sale. Piron had acquired it at the sale which followed the death of Delacroix, whose executor he was. Cézanne informed me that Delacroix, by his last wish, had given his heirs the right to choose any picture from among his works with the exception of this water-color, which was to figure at the sale of his effects. Wishing to show Cézanne the interest I had taken in his narrative, I looked up Delacroix's will, and the following day when I came to pose, I remarked, "I have read Delacroix's will; he actually does mention a large water-color representing flowers placed, as it were, 'at random against a gray background.'"

"You idiot," he shouted, taking a couple of steps in my direction and brandishing his fists in my face, "don't you dare say that Delacroix painted anything at random!"

I explained the misunderstanding; he calmed down. "I love Delacroix," he said by way of apology. Meanwhile I promised myself to redouble my precautions in the future. Another time, all omens presaged a favorable sitting; the sky was "clear gray," no dogs, silence in the pile-driver fac-

tory, a good copy the day before at the Louvre; and last but not least *La Croix* had announced a victory for the Boers that day. While I was rejoicing over these auspicious portents, I heard of a sudden a resounding oath, and turning around, I saw Cézanne wild-eyed, his palette-knife raised over my portrait. I was petrified with fear for what might happen; at last, after moments which seemed like hours, Cézanne turned his fury against another canvas, which was instantly reduced to shreds. The reason for his wrath, it seems, was this: in a corner of the studio opposite to where I was posing, there had always been an old faded carpet. On that particular day, unfortunately, the maid had taken it away with the laudable intention of beating it. Cézanne explained that it was intolerable not to have that carpet in its accustomed place; it would be impossible for him to continue my portrait; he would never touch a brush again as long as he lived. Happily he did not keep his word, but the fact remains that he could not paint another stroke that day.

After a hundred and fifteen sittings, Cézanne abandoned my portrait to return to Aix. "The front of the shirt is not bad"—such were his last words on parting. He made me leave the clothes in which I posed at the studio, expecting, when he returned to Paris, to paint in the two white spots on the hands, and then, of course, to work over certain parts. "I hope to have made some progress by that time. You understand, Monsieur Vollard, the contour keeps slipping away from me!" But he had not counted on the moths, "the little wretches!" which devoured my clothes in short order.

When Cézanne laid a canvas aside, it was almost always with the intention of taking it up again, in the hope of bringing it to the point of perfection. We can readily understand, then, those landscapes, already "classified" and taken up

again the following year—sometimes even two or three years in succession. This procedure did not bother him in the least, since for him, "to paint from nature was not a question of copying the subject, but solely of realizing his sensations." It is easy to see how, from this unheard-of conscientiousness, this perpetual repainting of his work, the legend gained credence that he was powerless to realize his visions. Cézanne himself did all he could to spread this belief; he would solemnly and with the utmost conviction tell you, "I don't seem to possess the power to realize." That epitomizes "Cézanne the provincial," darting furtive glances about him, and imagining himself hedged in by enemies whose sole purpose in life was to obstruct his admission to the Salon of Bourguereau. It was those imaginary enemies whom he tried to disarm with a humble, timid mien. What a contrast to "Cézanne the master," who, when someone bumped into him by accident one day at work, shouted furiously: "Don't you know that I'm Cézanne?"

His friends bantered him a great deal about his obstinate determination to get into the official Salons; but we must not forget his conviction that, if ever he could slip into the Salon of Bouguereau with a "well-realized canvas," the scales would fall from the eyes of the public, and they would desert Bouguereau to follow the great artist that he felt himself capable of becoming.

It is only fair to add that every trace of this conceit vanished the moment he sat down to his easel. Picture him with all his faculties concentrated on "the exactness of the form," searching out the line, with the same conscientiousness that the guild apprentices might have lavished on the *chef d'oeuvre* which was to bring them their mastership. If he were satisfied with a sitting, a very unusual occurrence, he

shouted like a schoolboy who has just received a good mark. Therefore it is not hard to understand how great must have been his irritation if he were suddenly awakened from his dreams and brusquely brought back to earth again. One day when someone had disturbed him at his work, and he had slashed up one of his pictures, he said to me, "Excuse me, Monsieur Vollard, but when I am studying, I must have absolute quiet."

CHAPTER IX

1899

WHEN echoes of the stir that Cézanne was making in Paris finally reached Aix, his compatriots, in their admiration for the "queer devil" who had succeeded in making the Parisians "sit up and take notice," began to show some esteem for him. They even went so far as to seek out his society, with the hope, of course, of extorting a canvas or two from him. It might turn out to be a good thing; "they bring good money in Paris now."

But all Provençals are distrustful, and Cézanne, who was no exception to the rule, with his constant terror of the famous "hooks," regarded their eulogies with suspicion. "Flatterers," to his mind, were even more dangerous than "mudslingers." He once told me in this connection that an art critic had sought to do him honor by picturing him with his arms thrown around a tree and crying with tears in his eyes, "If only I could transplant this to my canvas!" "Life's frightful, isn't it, Monsieur Vollard." His suspicions went to such lengths that one day, when a boyhood friend happened to meet him at Aix, and asked him where he lived, he said hurriedly, "I live a long way off, in a street." Once rid of the fellow, he muttered, "The beggar, he tried to get his hooks on me!"

There remained those who were neither familiar nor indiscreet, neither too reverent nor too respectful—in a word, all those against whom he could harbor no grudge. But even

with these it was hard for him to find any common ground, so great was his natural detachment. One day his cab was bringing him back from a *motif*. Inasmuch as the horse was having difficulty in negotiating a rather steep incline, Cézanne got down and walked beside the carriage. When they came to a level stretch, the driver whipped up his horse and went off at a trot. Meanwhile Cézanne plodded along mechanically, suspecting nothing. Imagine the cabby's stupefaction when he turned around and found his carriage empty. "That's the first time I've ever lost a fare!" the good fellow ejaculated. But he was not so surprised as Cézanne by half —he could not for the life of him explain what had occurred.

Another time, in the heat of an argument with Solari, a sculptor who lived at Aix, he swallowed a whole bottle of cognac without investigating the label, under the impression that it was mineral water. It goes without saying that the conversation waxed maudlin.

One of the rare good memories that Cézanne retained of his relations with his fellow men was a chance encounter with Monsieur Denys Cochin. The latter was out for a horseback ride with his son, Augustin Cochin, in the environs of Paris. The young man cried suddenly, "Look, father, there's Cézanne painting in that field over yonder."

"How do you know it's Cézanne?" asked the father, whose eyes were not as sharp as his son's.

"Because he's painting a Cézanne!" came the prompt reply. They drew nearer, and Cézanne who could never endure being disturbed while at work, was, contrary to his custom extremely affable. "I could tell at a glance that they were 'society' folk," he told me. But notwithstanding Monsieur Cochin's cordial invitation to come to his house and see his Delacroix and his Cézannes, the painter could never come to the point of making the visit. "I don't know how to act

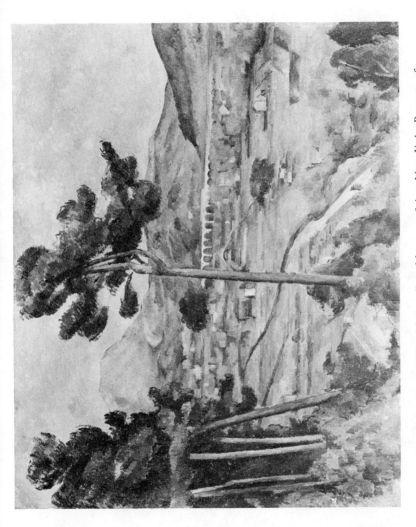

Mont Sainte-Victoire (The Metropolitan Museum of Art, New York; Bequest of Mrs. H. O. Havemeyer, 1929; the H. O. Havemeyer Collection).

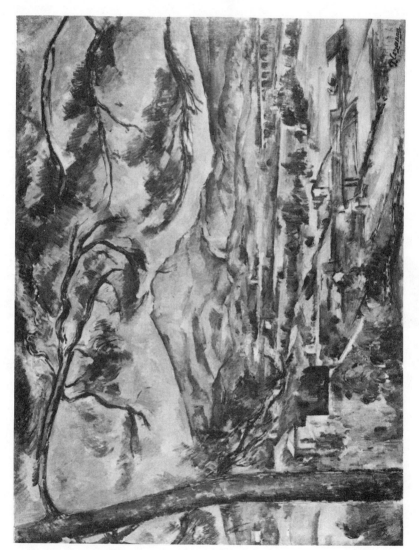

Mont Sainte-Victoire (Courtauld Institute Galleries, London).

in society," he protested after he had told me of the incident. Let us add that his misanthropy did not prevent him from being indulgent towards others if he were persuaded that they were not trying to "get their hooks on him." Some friends were talking one day in his presence of an Aixois who had eaten up his wife's entire dowry. Cézanne was the only one who did not become indignant over it.

"But tell me, can you find a single redeeming quality in that man?" asked one of the victim's relatives.

"Yes," replied Cézanne, "I believe he knows how to buy olives for the table."

Cézanne had that sickening fear of the "hooks" to blame for not finishing his portrait of Monsieur Gustave Geffroy. After a great many sittings he abruptly packed up his paint-box and easel and skipped off to Aix. One day we were talk-ing about Monsieur Geffroy's writings: "You must read his *La Coeur et L'Esprit,*" said Cézanne. "Among other fine things in that book there is a short-story called *Le Sentiment de l'Impossible.*" I ventured to ask him why he never saw Monsieur Geffroy any more. He replied, "Don't misunder-stand me; Geffroy is a nice enough fellow, and he has lots of talent, but he's forever talking about Clemenceau; so I came back to Aix to save my life!"

"Clemenceau is not your sort then?" I asked.

"It's not that, Monsieur Vollard! He has temperament; but for a man like me, who is helpless in this life, it's safer to lean on Rome!"

It was no affliction to Cézanne that nature should have denied him the gift of normal sociability; his wife, his son, and his sister Marie were all he asked for. And then, were not the good red soil, the verdant pines, and the blue hills of his own Provence treasures more precious than all human-ity put together? There in Provence he hoped to end his days,

and there, in fact, he retired definitely towards the end of the
year 1899, scarcely a day after he ceased work on my portrait.

When he had decided to reside at Aix for good, thus flee-
ing the society of his kind, he made the resolve to imitate the
more "proper" people of the town, and if circumstances
should oblige him to mingle with other people, to take some
pains about his personal appearance—at least if he should
think of it at all—and always compel himself to behave be-
fore compatriots and stranger alike with imperturbable polite-
ness. From now on the only thing that could provoke a change
in his attitude was an attack directed against some painter
that he admired, or else praise of Dubufe, Robert Fleury, or
some other artist of the same stripe. He had always been
incorrigible in that respect. His weakness never showed itself
to better advantage than in the course of the parleys pre-
ceding a duel in which Zola came near being embroiled in
his youth, and at which Cézanne and Guillemet acted as wit-
nesses. The latter, who was not unaware of the danger of
bringing Cézanne face to face with painters whom he scorned,
had hastened to catechize him and enjoin upon him the ut-
most moderation in the company of Olivier Merson and an-
other master of the same school, who were the witnesses for
the other party. To these wise counsels, however, Cézanne
invariably replied: "They all give me a pain!" Nevertheless,
everything went smoothly enough. A conciliatory letter, in
which Zola made fun of his adversary in the most agreeable
manner in the world, had been presented by his seconds and
accepted, unquestioned. Emboldened by this apparent success,
Olivier Merson took Zola to task for the opinions he set forth
on art in the papers. His gorge rose a little at Zola's audacity
in attacking such painters as Bonnat, Cabanel, Fromentin and
others. Guillemet had hardly had time to call Merson's at-
tention to the fact that it was none of his business, when

Cézanne, who up to that moment had been busy scratching the calf of his leg and had taken no part in the conversation, jumped up furious.

"I say to hell with Cabanel!"

As soon as they were outside, he took Guillemet to task: "We were too damned soft. You're strong, why didn't you knock him down?"

Timid and helpless in the ways of the world, Cézanne rather distrusted soldiers on leave. But these same soldiers, kept well in hand, and ready without cavil to march against enemies from without as well as from within, seemed to him a blessing from on high. Of course his love for his dear army had made him anti-Dreyfus. Accordingly, after Rodin had published a letter deploring the fact that there were none but Dreyfus supporters among the subscribers to his statue of Balzac, Cézanne almost came to the point of sending in a subscription himself. "That chap *Rodenn* has the right idea. He's a good fellow; he ought to be encouraged."

Likewise he could not tolerate the clergy from the very day that he had met with a "scoundrelly abbot," a "dirty cassock" who played the organ at Saint-Sauveur, and, what was worse, played off key. "I can't attend mass any more," he said, "on account of that dirty hound. His playing makes me positively ill."

Although Cézanne did his best to avoid priests as a class, he felt that religion had its good points, that it made for "respectability," and provided a "moral support." Therefore he went to the churches and attended mass on Sunday. From early childhood he had evinced decidedly conservative tendencies. One day his father had said jokingly to a friend, "We are having dinner a little late today. It's Sunday, so the ladies have gone to eat the Lord God." Whereupon the son, customarily so subdued, flared up boldly against the author of

his days: "It's easy to see that you read *Le Siècle,* with its
wine-merchant politics!" When it happened, however, that
on Sunday the sky was clear gray, the curate had to get along
without Cézanne.

He never ceased to dream about his painting, even at mass.
A young artist had made a pilgrimage to Aix to try to see
the master. It happened to be Sunday. One of the young man's
friends, who was acting as his guide, conducted him, as a
matter of course, to Saint Sauveur, where mass was just
letting out. When Cézanne had been pointed out to him, the
youthful disciple rushed up to the master. Thus unexpectedly
accosted, Cézanne was as frightened as a rudely awakened
sleeper. The surprise was so great that he dropped his prayer
book. But as soon as the other had told Cézanne that he was
a painter, the master cried, "Ah! so you're one of us?" and
was as amiable as could be. Then suddenly clutching a button
on the young man's jacket, he said earnestly: "Listen! Every-
thing in Nature is a cylinder or a cube." A moment later:
"Look!" and he pointed to a beam of sunlight reflected in a
tiny stream that ran through the square, "how would you
paint that? You must be on your guard against the Impres-
sionists, I tell you. Just the same, they know how to see!"

Notwithstanding his strong religious sentiments, Cézanne
would consign the Almighty to the nethermost Hell on the
merest pretext, unless some other victim upon whom he could
vent his anger happened to be within reach. I recall one day
that the fog had driven him out of the studio while he was
painting my portrait. Just as he was about to take the name
of the Lord in vain, he remembered that Carrière was his
next door neighbor; whereupon he shook his fist at his con-
frère's windows, pretending to be furious, but with an antici-
patory twinkle in his eye. "He's in luck—it's ideal weather

for Carrière to give himself up to one of his orgies of color!"

Cézanne was as delighted as a child with these cheap little remarks. A long time ago when the slang phrase of the day was "Ho there, Lambert!" he espied, while strolling in the environs of Paris, a genial painter of cats, with whom he was acquainted. His name happened to be Lambert. Feeling in the mood for a little joke, he cried: "Ho there Lambert," putting, or at least intending to put, a damper in his voice. The other wheeled about, and naturally enough started towards him. Cézanne, frightened out of his wits, and thinking that he had a fight on his hands, picked up a stone and made ready to defend his life at any cost. Lambert advanced smiling, his hand outstretched, happy to have found someone he knew. "Don't pay any attention to those guttural noises that come from my throat," said Cézanne. Lambert would have none of his excuses, and shook hands heartily. They walked along together, but Cézanne was on his guard. When one is "helpless in the ways of the world. . . ."

CHAPTER X

CÉZANNE had spoken to me of certain canvases of his youth that he had given to Zola. I was very anxious to see them. Monsieur Mirbeau, to whom I had mentioned my desire, expressed his willingness to give me a letter of introduction to Zola. In the letter, however, he refrained from speaking of the pictures. "Zola is so jealous of them that I dare not ask him to show them to you," he said. Mirbeau merely explained in his letter that I was in search of a suitable type-face for a coming edition of the *Jardin des Supplices,* and that I should be greatly indebted if Zola would show me a testimonial recently sent to him by a group of Belgian adherents of Dreyfus, and printed with the celebrated Plantin type.

When I arrived at Zola's house, I was conducted through an entrance-hall in which was displayed an immense composition by Debat-Ponsan, representing *Truth Arising from the Well.* It bore the legend *Nec mergitur,* and was inscribed: "Truth, raising her mirror, strives to emerge from the well, but is held back by the hypocrisy of Basile and the rude hand of Brutal Force." Presently I was ushered into a drawing-room filled with objects of piety. The light came in through two glass windows, one representing scenes from mythology, and the other showing Coupeau cutting a loaf of bread. I could not help but admire such eclecticism. A delicious calm pervaded the place, and I understood for the first time the grandeur of Zola's sacrifice when he left this exquisite home

to defend Innocence, in the infested atmosphere of public meetings.

The master appeared presently, clasping to his breast the much adored Pinpin, one of the ugliest and most quarrelsome little dogs that I have ever seen, and holding in his disengaged hand a copy of *La Débâcle*. He caught me stealing a glance at Coupeau; his countenance was benevolent.

"Ah yes, the Plantin type," he said, after he had acquainted himself with the contents of my letter of introduction. "I shall try to put my hand on that testimonial from my Belgian admirers; but I receive so many testimonials, from all corners of the globe; it is quite possible that some of them may have been lost. In any case, you will have no difficulty in finding a type at any of our great modern type-founders that is just as good, perhaps even better. It is incredible that, since the days of Plantin, the art of printing could alone have been out of harmony with the progress which is being manifested in all the other arts."

I refrained from turning the trend of the conversation toward the Cézannes as yet, fearing to awaken Zola's suspicions. My game was to lead the master to speak of them himself. I ventured to express my admiration for the objects which adorned the salon.

"And my Debat-Ponsan?" he interrupted. "The thing that makes that *Truth Arising from the Well* so moving is that one can fairly hear the conscience of an honest man crying out. When the painter was presented to me, and I expressed my admiration for his work, he said to me with tears in his eyes, 'I was so intent upon revealing the naked soul of the abominable Basile that I never realized that at the same time I was painting the most successful canvas of my artistic career. The credit is not due to me; it was not my hand but my heart that guided my brush.' Ah! that man is more than a

great painter, he is a fine character who has become a great painter; and it is because he *is* a fine character that great genius has come to him. What a lesson for artists who fail to put their manhood first! They never paint masterpieces, because it is with the heart's blood that one writes, paints, carves, a great work. . . ."

Myself (timidly) : It seems to me that the figure of Truth, and even Basile, have already begun to blacken a little.

Zola : The greatest masters blacken in the long run. Should we cease to admire them on that account?

I went over to examine an ivory angel which was suspended from the ceiling by means of a fine wire. With its wings outstretched, it gave the illusion that it was flying of its own accord.

"What a lovely angel!" I exclaimed.

Zola : It is said to be thirteenth century, but I assure you that I don't bother myself about periods or styles. An artist demands of an object of art simply that it should give him pleasure, nothing more.

Myself : It is almost like a museum here.

Zola : Before writing a book, I always gather a store of material. It was in the company of these countless charming nothings that I wrote *Le Rêve*.

Myself : Did you discover all these treasures in Paris?

Zola : I did not have to go far afield. The entire crop was harvested in my neighborhood at very fair prices. Opportunities are always presenting themselves, but so few people know how to see!

Myself (perceiving, in a pretty, up-to-date frame, a portrait of a young girl warming a tiny bird between her bared breasts) : The influence of Greuze?

Zola : Connoisseurs have even attributed it to Greuze.

Myself (discovering, in the neighborhood of the girl with

the bird, a picture representing a group of nude female figures suspended from the vault of Heaven by means of silver chains) : Ary Scheffer?

Zola : It is one of the masterpieces of that passionate lover of the ideal who painted nothing but masterpieces: the Corneille of painting, a perfect companion to its Racine, our own Greuze.

Zola's face beamed with such good will that I ventured to speak about Cézanne.

"There is a question on the tip of my tongue, Master, but I have already abused your hospitality to such an extent. . . ."

Zola (indulgently) : Speak!

Myself : It is about the letters that you wrote to Monsieur Cézanne, and which are so indispensable to the world today, to teach it to feel and to think. Are they still in existence? I have not dared to speak to Monsieur Cézanne about them, because I did not want to give him reason for eternal remorse; for, if he had not preserved those precious papers, he would have been overwhelmed with the realization of how basely he had betrayed the confidence of posterity.

Zola : I too was afraid for those letters. I gave the best of myself in them! But thanks be to Heaven, Cézanne had sense enough to treasure the merest note that I wrote him with the greatest care. When I asked him to give me back my correspondence, thinking that its publication might prove to be invaluable to young artists, who could not fail to profit by the advice that a friend gave to a friend from the bottom of his heart, he returned the package—not a letter was missing. Ah! why did he not also give me the great painter upon whom I counted so much!

Myself : What confidence you must have placed in Monsieur Cézanne!

Zola : His comrades were ready enough to set him down

as a failure, but I told them over and over again: "Paul has the genius of a great painter." Ah! why was I not a good prophet?

Myself: But Monsieur Cézanne was a terrific worker, and besides he had the imagination of a poet!

Zola: Dear big Cézanne had the divine spark! But, if he had the natural genius of a great painter, he did not have the persistence to become one. He lost himself too much in his dreams, dreams that were never fulfilled. To use his own words, he gave himself to be nursed by illusions!

Myself: Have you any pictures by Monsieur Cézanne?

Zola: I have hidden them away in the country. At the suggestion of Mirbeau, who wanted to see them, I had them sent back here. But I could never put them on the walls. My house, you understand, is the rendezvous of artists. You know how fair-minded they are, yet severe with each other. I could not bear to leave my best friend, the companion of my youth, to their tender mercies. Cézanne's pictures are under triple lock and key in a cupboard, safe from mischievous eyes. Do not ask me to get them out; it pains me so to think of what my friend might have been if he had only tried to direct his imagination and work out his form. One may be born a poet, but a good workman has to be made.

Myself: I presume, Master, that you gave him the benefit of your advice and wide experience?

Zola: I did everything to bring dear old Cézanne back to his senses; the letters that I wrote to him moved me so deeply that I can remember them word for word. It was he who inspired *l'Oeuvre*. The public went mad over the book, but Cézanne was indifferent. After that nothing could bring him out of the clouds; he withdrew more and more from the work-a-day world. . . .

These last words, uttered in a trembling voice, were followed by a silence.

Myself: But even if he was never able to "realize" his ideas, perhaps Monsieur Cézanne said some interesting things about painting in his letters?

Zola (putting down his little dog tenderly) : Everything that Cézanne wrote was unexpected and original. But I have not kept his letters. I would not, for the world, have anyone else read them, on account of their somewhat loose form. . . .

Myself (interrupting) : There again your friendship. . . .

Zola: All that is so long ago! In reply to one of those missives of his—so pungent with the sweet fragrance of Provence—I remember writing to him: "I love those strange thoughts of yours; they are so like young gipsy girls with their quaint glances, their muddy feet, and their glorious, flower-crowned heads." But I could not help adding, "Our sovereign master, the Public, is not so easy to satisfy. He says 'fie upon princesses dressed in rags. . . . To win grace in his eyes it is not sufficient merely to say something—one must say it well.' "

At this juncture a crowd of children trooped by the windows of Zola's house, shouting "Down with Zola, down with Dreyfus!" I said politely, "The little wretches!" and the diminutive dog yapped furiously. But Zola's face was bland with the serenity of a martyr marching to the sacrifice.

"No, not wretches, just poor misguided souls, blind with too much light! No more can the owl see at high noon!"

And burying his face in Pinpin's fur, he cooed to the dog, "You're not wicked, are you?" Then he murmured, "They have eyes and they see not; ears they have and they hear not. . . ."

Myself: It is not blindness alone that one deplores in one's enemies, Master. There is hate, deliberate hate. . . .

Zola: Yes, hate. I have been made very unhappy by it—I who should so have liked to be beloved of all!

Myself: Master, you have the élite of the thinkers on your side.

Zola: But the crowd rejects me.

Myself: The serpents of envy are not long lived. The day will come when their eyes will be unsealed. Already I have heard the cry: "Long live Zola!"

Zola: Perhaps tomorrow the same ones will hiss me.

Myself: But remember, your editions are running up to one hundred and fifty thousand copies.

Zola: That's nothing to the editions of a million copies that Jules Mary gets in *Le Petit Journal.*

And Zola, a far-away look in his eyes, murmured to himself, *"Le Petit Journal,* a million copies!"

In order to give a more cheerful turn to this depressing subject, I recounted what I had been told of the huge sales of his *La Débâcle* in foreign countries. Zola replied, "That, of all my books, has been most appreciated by the public."

Myself: Is it the one you like the best, Master?

Zola: An artist always prefers the thing he is *going* to do. But I must admit that I have a warm place in my heart for *La Débâcle;* the sales have reached the two-hundred-thousand mark.

With these words I took leave of Cézanne's illustrious friend.

Zola's death in 1902 affected Cézanne very deeply. The first news of it reached him when he was at his studio in Aix, in the act of setting his palette. Paulin, a former boxer, who served Cézanne in the dual capacity of servant and model, burst into the room and cried: "Monsieur Paul, Monsieur Paul, Zola is dead!" Cézanne burst into tears. He motioned

the model away and locked himself in. Although not daring
to knock, Paulin came to the door from time to time and
listened. His master wept and sobbed all day long.

The Cézannes which were found when Zola's cupboards
and granary were emptied were sent to the Hotel Drouot,
along with the indiscriminate mass of antiquities which em-
bellished his salon. The sale took place in March, 1903. It
is worthy of note that one of Zola's admirers bid *Truth Aris-
ing from the Well* up to three hundred and fifty francs.

Rochefort, ill-informed on this point, and imagining that
Zola admired the art of Cézanne, launched a scathing attack
in *l'Intransigeant* against this kind of painting, and withered
the eccentricities of the deceased with his most caustic irony.[1]
The article concluded as follows: "Seeing Nature through
the eyes of Zola and his painter-associates, is like seeing
patriotism and honor in the guise of an officer betraying the
defenses of his country to the enemy."

I recall an amusing incident in this connection. Cézanne
fils had written to his father that he had put Rochefort's
article aside for his perusal. Cézanne replied: "Don't bother
to send it. I find it thrust under my door every day, and any
number of copies come by every post."

One day Cézanne was showing me a little portrait of Zola
painted in the period of his youth, about the year 1860. I
seized the opportunity to ask him at what period Zola and
he had broken with each other. "No harsh words ever passed
between us," he replied. "It was I who stopped going to see
Zola. I was not at my ease there any longer, with the fine
rugs on the floor, the servants, and Emile enthroned behind
a carved wooden desk. It all gave me the feeling that I was
paying a visit to a minister of the state. He had become (ex-

[1] March 9, 1903.

cuse me, Monsieur Vollard—I don't say it in bad part) a dirty bourgeois."

Myself: I should think it must have been frightfully interesting to meet Edmond de Goncourt, the Daudets, Flaubert, Guy de Maupassant and all those people at Zola's house.

Cézanne: Oh, there were plenty of people there, but the things they talked about made me sick. I tried to arouse interest in Baudelaire once, but nobody cared anything about *him*.

Myself: Then what *did* they talk about?

Cézanne: Each one talked about the number of copies he had had printed of his last book, or how many he hoped to have printed of his next. Of course, they exaggerated a little. But you should have heard the women! Mme. X. would say proudly, casting a defiant look at Mme. Z.: "My husband and I have figured that the last novel, with the illustrated editions and the 'popular edition,' has reached thirty-five thousand copies." "And *we*," Madame Z. would say, taking up the challenge, *"we* are promised by contract an edition of fifty thousand copies for our next book, not counting the edition *de luxe."*

Myself: Were they all authors of best sellers or vain wives? Surely Edmond de Goncourt. . . .

Cézanne: No, he was never vulgar about it; but just the same, he made a wry face whenever he heard a new record!

Myself: Do you like the Goncourts?

Cézanne: I used to like *Manette Salomon* very much, but I have never read any Goncourt since the "widow," as Barbey d'Aurevilly called him, began to write alone.

At that time I went to see Zola only on rare occasions—it distressed me to watch him grow so stupid. Then one day a servant told me that his master was not at home—not to anybody. I don't know whether the instructions were meant

for me in particular, but I went still less frequently. . . .
And then Zola wrote *l'Oeuvre*. . . .

Cézanne was silent for a moment, overwhelmed by the
past. He continued.

"You can't ask a man to talk sensibly about the art of
painting if he simply doesn't know anything about it. But
by God!"—and here Cézanne began to tap on the table like
a deaf man—"how can he dare to say that a painter is done
for because he has painted one bad picture? When a picture
isn't realized, you pitch it in the fire and start another one!"

As he talked, Cézanne paced up and down the studio like
a caged animal. Suddenly seizing a portrait of himself he
tried to tear it to pieces; but his palette knife had been mis-
laid, and his hands were trembling violently. So he rolled
the canvas up, broke it across his knee, and flung it in the
fireplace.

Myself: But Zola talked to me about you at such length
and in such affectionate terms. . . . I don't understand. . . .

Cézanne looked at me with sorrowful eyes. The destruc-
tion of his canvas had calmed him. His anger had given
way to pain.

"Listen, Monsieur Vollard, I must tell you. Although I
stopped going to see Zola, I never got used to the idea that our
friendship was a thing of the past. When I moved next door
to him, in Rue Ballu, it had been many moons since we
had seen each other; but living so near to him I hoped that
chance would bring us together often,—perhaps he would
even come to see me. . . . Later, when I was in Aix I heard
that Zola had arrived in town. I presumed that he would
not dare to look me up of course; but why not bury the
hatchet? Think of it, Monsieur Vollard, Zola was in Aix!
I forgot everything—even that book of his,[2] even that damned

² *L'Oeuvre.*

wench, the maid, who used to look daggers every time I scraped my shoes on the matting before entering Zola's drawing room. When I heard the good news, I was in the field, working on a fine *motif;* it wasn't going badly either; but I chucked the picture and everything else—Zola was in Aix! Without even taking time to pack up my traps, I rushed to the hotel where he was stopping. But on the way, I ran into a friend. He informed me that someone had said to Zola on the previous day, 'Aren't you going to take a meal or two with Cézanne before you go?' and Zola had answered, 'What do I want to see that dead one again for?' So I went back to my work."

Cézanne's eyes were full of tears. He blew his nose to hide his emotion.

"Zola was not spiteful, Monsieur Vollard, but his life was circumscribed by events."

To change the subject, I asked him, "Why did Zola want to become a member of the Académie Française?"

Cézanne: The real cause dates a long way back. After the appearance of *l'Oeuvre,* there was a quarrel between Zola and Edmond de Goncourt. Zola was ostensibly forgiven, but Goncourt scratched him off of the list for his Academy. In order to get back at him, Zola wanted to become a member of the other academy. If they had accepted him, he would have been quite contented, for then he wouldn't have had to mix up with that Dreyfus affair in order to make the world open its mouth and gape. He didn't know much about the Dreyfus argument anyway. But when a man is a bit "thin," he always tries to bite off more than he can chew. You've got to have "temperrammennte" to succeed in this world, Monsieur Vollard!

Myself: But what did Goncourt find to take offense at in *l'Oeuvre?*

Cézanne: He objected to the title that Zola had used. He pretended that the word *l'Oeuvre* belonged to him and to his dead brother, because they had written *l'Oeuvre de François Boucher!*

Cézanne began to laugh heartily; then, his eyes twinkling with malice, he chuckled, "Artists are never such asses, as that, are they, Monsieur Vollard?"

For the sake of argument, I mentioned the case of Rosa Bonheur, who, to avoid competition, forbade her poor relatives, whom she aided liberally enough in other ways, to paint animals in the foregrounds of their landscapes.

Cézanne had pricked up his ears at the mention of an obstacle in the path of a painter's progress. But such a hindrance, in his eyes, was not calculated to stop anybody from painting. It was quite enough to have "temperrammennte."

He asked me what the collectors thought of Rosa Bonheur. I replied that they usually agreed that *Nivernaise Husbandry* was quite fine. "Yes," countered Cézanne, "it's horribly realistic."

CHAPTER XI

CÉZANNE would have liked very much to have been decorated, but he never could come to the point of making overtures in his own favor, in spite of the immense pleasure it would have given him to "have the laugh on the Institute crowd" and the people of Aix.

In 1902 Monsieur Mirbeau—he could not for the life of him have told why—decided to sound Monsieur Rujon, then director of the Beaux-Arts, on the subject of a cross for Cézanne. Mirbeau had no sooner said that he was pleading the cause of a certain painter for the cross than the superintendent, presuming that his visitor had the judgment not to demand the impossible, reached for the drawer which contained the ribbons committed to his keeping. But the name of Cézanne made him jump. "Ah! Monsieur Mirbeau, while I am director of the Beaux-Arts I must follow the taste of the public and not try to anticipate it! Monet if you wish. Monet doesn't want it? Let us say Sisley, then. What! he's dead? How about Pissarro?" Then, misinterpreting Monsieur Mirbeau's silence: "Is he dead too? Well then, choose whomever you wish. I don't care who it is, as long as you do me the favor of not talking about Cézanne again!"

Thus the master lost his only opportunity of being decorated by the Beaux-Arts. He consoled himself by working more furiously than ever, with the hope of some day break-

ing down the barriers to the Salon of Bouguereau. He wrote
to me:

<div align="right">Aix, April 2, 1902</div>

DEAR MONSIEUR VOLLARD:

I find myself obliged to postpone sending your painting of
roses until a later date. Although I should have liked very
much to have sent something to the Salon of 1902, I must let
another year go by before carrying out my intention, for I am
not satisfied as yet with the results obtained. At all events, I am
not neglecting my work. It makes heavy demands upon me,
but I like to believe that it will not be sterile. I have had a
studio built upon a bit of land which I acquired for the purpose
and I am pursuing my researches there. As soon as I am satis-
fied that they have borne fruit, I shall inform you of the results.

<div align="center">Believe me, most cordially yours,</div>

<div align="right">PAUL CÉZANNE</div>

A few months later I received another letter:

<div align="right">Aix, January 9, 1903</div>

DEAR MONSIEUR VOLLARD:

I work obstinately, and once in a while I catch a glimpse of
the Promised Land. Am I to be like the great leader of the
Hebrews, or will I really attain unto it?

If my canvas is ready by the end of February, I shall send
it to you to be framed and sent to some friendly haven.

I have had to lay aside your canvas of flowers; I am not
satisfied with it. I have a large studio in the country. I can work
better there than in the city.

I have made some progress. Oh, why so late and so painful!
Must Art indeed be a priesthood, demanding that the faithful
be bound to it body and soul? I regret the distance that sepa-
rates us, for more than once I have wished for your moral
support. I live alone; the ——s and the ——s are unbearable;
good Lord, they are intellectuals of the worst stripe. If I live
long enough, we shall talk that all over. Many thanks for your
good wishes.

<div align="right">PAUL CÉZANNE</div>

In 1904 Monsieur Roger Marx, an inspector of the Beaux-Arts, who was aware that Cézanne coveted the cross, but realized full well that there was nothing to be expected from the Minister, tried to secure him a decoration, at the time of the Universal Exposition at Saint Louis, from the Minister of Commerce and Industry. But the pictures had to pass a jury first, before being sent to America. Cézanne's champion, anxious to forestall any possible pretext for refusing the picture which was to be submitted, delegated me to choose from among his works the most "reasonable" canvas that I knew. I proposed *My Garden,* which had figured in the Centennial during the Paris Exposition of 1900. A new obstacle: those members of the jury who belonged to the old school—and they were decidedly in the majority—remembered with bitterness that the organizer of the Centennial, the self-same Roger Marx, had in that instance accepted for exhibition three canvases by Cézanne, whereas he had admitted but one work apiece by equally indisputable artists such as Cabanel and Bouguereau. Needless to say, *My Garden* was rejected unanimously.

In the same year, 1904, the Salon d'Automne devoted an entire room to Cézanne. Puvis de Chavannes also had a separate salon. One of the newspapers, in reviewing the show, deplored the fact that the exhibitors were listed in the catalogue in alphabetical order, thus placing Cézanne's name before that of Puvis! The Press was as hostile as ever; but from now on Cézannes began to be more and more desirable in the eyes of the collectors. He had "arrived" in the accepted sense of the word.

In the following season[1] Cézanne again sent several can-

[1] Monsieur Ch. Morice, in his "Inquiry into the present tendencies in the plastic arts," published in *Le Mercure de France* in 1905, put this question before several artists: "How do you rate Cézanne?" Here are some of the replies:

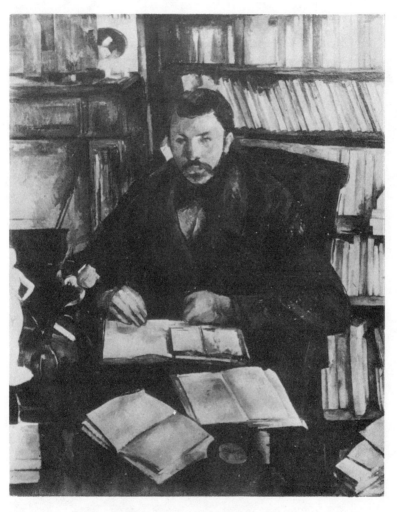

Gustave Geffroy (M. Lecomte Collection, Paris).

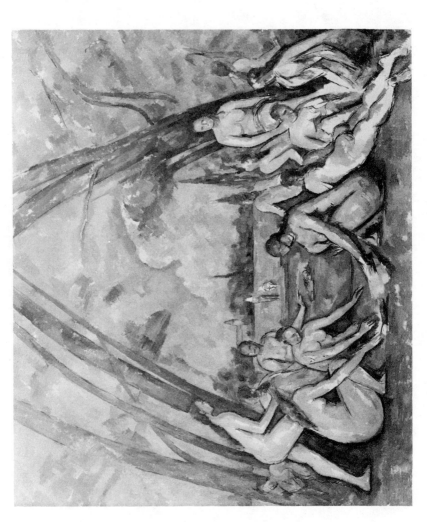

The Large Bathers (Philadelphia Museum of Fine Art, Pennsylvania; from the

vases to the Salon d'Automne, among them the *Portrait of Geffroy,* 1890; *Bathers* and a *Bouquet of Roses,* done after an engraving (these two pictures were part of the Caillebotte bequest) ; *The Harvesters,* etc.

About the end of that year, I went to Aix. I found Cézanne reading *Athalie.* On the easel was a still-life, begun several years before, of some skulls on an Oriental tapestry.

"A skull is a beautiful thing to paint!" he exclaimed. "Look, Monsieur Vollard," and he pointed to the study.

He based great hopes on that canvas. "I think I'm going to realize at last!" he said. After a pause: "So Paris thinks my work is pretty good, eh? Ah! if Zola were only there, now that I'm bowling 'em over with masterpieces!"

I told Cézanne that Léon Dierx had asked to be remembered to him. "I am very much touched that Léon Dierx should have kept such a warm place in his heart for me," he replied. "Our acquaintanceship dates back many years. I met

E. Schuffenecker—Cézanne has never painted a picture nor has he a single *work* to his credit.

Tony Minartz—As for Cézanne, I say nothing and think less, for I am not entrusted with the sale of his work.

M. L. de la Quintinie—Cézanne is a great artist who lacks training.

Gabriel Roby—Cézanne has fine temperament, but he gives evidence of no conscious development.

Henry Hamm—Cézanne's evident sincerity intrigues me; his clumsiness astonishes me.

Ouvré—A friend of mine has said, he sees the nude "cross-eyed."

Ignacio Zuloaga—I like Cézanne in his good canvases.

Fernand Piet—Cézanne? Why Cézanne?

Victor Binet—I have nothing to say about the paintings of Cézanne. They look like the work of a drunken night-man.

Henri Caro-Delvaille—As far as Cézanne is concerned, I agree with Puvis de Chavannes: an artist, if left to the mercies of sheer instinct, never gets beyond the infant-prodigy stage.

Maxime Dethomas—I consider Cézanne an agreeable colorist.

Paul Signac—A still-life by Cézanne or a thumb-box sketch by Seurat are just as fine painting as the Mona Lisa.

Adolphe Willette—I give you my word, I would never sink three thousand "bob" in the purchase of three "woolly" apples on a dirty plate.

Albert Bernard—Cézanne? Rubbish!

him for the first time in 1877 at Nina de Villard's in Rue des Moines. Alas! the memories that are swallowed up in the abyss of the years! I'm all alone now; I would never be able to escape from the self-seeking of human kind anyway. Now it's theft, conceit, infatuation, and now it's rapine or seizure of one's production. But Nature is very beautiful. They can't take that away from me!"

That was my last conversation with Cézanne. I never saw him again.

In spite of a malady [2] from which he had suffered for long, and which had robbed him of much of his strength, Cézanne worked away with unflagging ardor. Some time before his death, he said to one of his friends, "I think I must have a blood-clot somewhere in my system." But a letter written to his son about the same time bears little trace of such apprehensions.

Aix, October 15, 1906

My dear Paul:

Saturday and Sunday it rained in buckets. So the air is much fresher. It isn't hot either. You were quite right when you said that this is a "low province." I still work with difficulty, but I seem to get along. That is the important thing to me. Sensations form the foundation of my work, and they are imperishable, I think. Moreover, I am getting rid of that devil who, as you know, used to stand behind me and force me at will to "imitate"; he's not even dangerous any more.

When you have the chance, say "how do you do" to Monsieur and Madame Legoupil, who were so kind as to remember me. And don't forget Louis and his family, and Papa Guillaume. Time passes with terrifying rapidity. My health is not bad. I take care of myself, and I have a good appetite.

I must ask you to order me two dozen *émeloncile* brushes, like the ones we ordered last year.

I would have to be twenty years younger, my dear Paul, to send you as satisfactory news as you would like.

[2] Diabetes. (*Trans. Note*)

I repeat, I have a good appetite, but a little mental satisfaction would do a lot for me. (As far as that goes nothing but work can give me that.) All my compatriots are asses compared with me. I embrace you and your mother. Your old father,

PAUL CÉZANNE

I think the younger painters are much more intelligent than the others; to the old ones I am just a disastrous rival.

Your loving father,
PAUL CÉZANNE

Two days after Cézanne had written the above letter, he was caught in a storm while working in the field. Only after having kept at it for two hours under a steady downpour did he start to make for home; but on the way he dropped exhausted. A passing laundry-wagon stopped, and the driver took him home. His old housekeeper came to the door. Seeing her master prostrate and almost lifeless, her first impulse was to run to him and give him every attention. But just as she was about to loosen his clothes, she stopped, seized with alarm. It must be explained that Cézanne could not endure the slightest physical contact. Even his son, whom he cherished above all ("Paul is my horizon," he used to say), never dared to take his father's arm without saying, "Permit me, papa." And Cézanne, notwithstanding the affection he entertained for his son, could never resist shuddering.

Finally, fearing lest he pass away if he did not have proper care, the good woman summoned all her courage and set about to chafe his arms and legs to restore the circulation, with the result that he regained consciousness without making the slightest protest—which was indeed a bad sign. He was feverish all night long.

On the following day he went down into the garden, intending to continue a study of a peasant which was going

rather well. In the midst of the sitting he fainted; the model called for help; they put him to bed, and he never left it again. He died a few days later, on October 22, 1906.

CHAPTER XII

CÉZANNE AND THE CRITICS

J. K. HUYSMANS, *Certains*. . . . An artist with diseased retinae, who, exasperated by faulty vision, has discovered the prodromes of a new art."

L'Art Français, Nov. 23, 1895: . . . Cézanne, of the proud line of Gauguin.

L'Art International, Nov. 25, 1895: . . . Cézanne comes midway between Puvis de Chavannes and Van Gogh.

Revue d'Art, First year 1899, No. 6 (Georges Lecomte): . . . Because Cézanne has no other guide but his instincts, he gropes, he hesitates. He evidences the awkwardness and imperfection of a true primitive. Can he really paint landscapes? He grasps their character, their color, their light. He translates their intimacy and their grandeur, but he runs aground in the art of separating his planes, and in giving the illusion of distance. His meagre knowledge betrays him.

1. Salon d'Automne of 1904

Le Journal, Oct. 14, 1904 (Marcel Fouquier): . . . At first glance, the things that distinguish Monsieur Cézanne's pictures are the awkwardness of their design and the heaviness of their color. His much vaunted still-lifes are brutal in handling and dull in effect. It has been predicted that they will go one day to the Louvre to keep company with Chardin. Happily that day is still far distant.

Le Gaulois, October 14, 1904 (Fourgaud): . . . the crude art of Monsieur Cézanne. . . .

Le Petit Parisien, October 14, 1904 (Valensol) : . . . Here is an artist who is sincere; he has ardent admirers; doubtless he could paint otherwise. . . . But he chooses to daub paint on a canvas, and spread it around with a comb or a toothbrush. This process produces landscapes, marines, still-lifes, portraits . . . if he is lucky. The procedure somewhat recalls the designs that school-children make by squeezing the heads of flies between the folds of a sheet of paper.

Le Petit Journal, October 14, 1904: . . . Finally, to finish up the special rooms, let us say that there is one devoted to Monsieur Paul Cézanne, and add nothing further.

La République Francaise, October 14, 1904 (de Bettex) : . . . I shall let Cézanne's admirers pronounce a eulogy upon his method, which may be summed up by saying that by planes, he sketches heads calculated to beguile the infant spectators at the Punch and Judy. . . . It takes a Goya to paint with mud.

New York Herald, Paris edition, October 14, 1904: . . . Cézanne has concocted a still-life; varnished apples in unbalanced bowls. They say that he is another Chardin; in any case, he will have imposed on the younger generation the emblematical little green pear. . . .

La Lanterne, October 15, 1904 (A.M.) : . . . Cézanne! A name which, in the heroic days of realism, was the signal for pitched battles! Alas! I fear that this exhibition will put an end to the quarrel by demonstrating in a most preemptory fashion that Cézanne is nothing but a lamentable failure. Perhaps he has ideas, but he is incapable of expressing them. He seems not to know even the first principles of his craft.

La Revue Illustrée, Oct. 15, 1904 (Ponsonailhe) : . . . I was in the act of innocently admiring some apples painted in vigorous tones, when one of my very elect friends proposed to show me that I had no more of an eye for pictures than a

lawyer's clerk. The marvellous thing, mind you, is the geometrical volume of the arms and legs in one or two sketches from the antique—volume, full of imagination, my expert assured me. In that respect Monsieur Cézanne is a lineal descendant of Phidias. A portrait of a man (it looks to me like a gas-fitter all decked out for Sunday) connects him with Poussin. My spirit is willing enough, but my eyes haven't had the proper training.

L'Eclair, Oct. 15, 1904: . . . I am at a loss to understand the room devoted to the pictures of the painter Cézanne side by side with a room devoted to the works of the revered master, Puvis de Chavannes. To put two personalities so different from each other (I am being polite) on the same footing as attractions, is not eclecticism—it merely shows a lack of tact.

L'Evénement, Oct. 18, 1904 (Le Senne): . . . Cézanne gives the impression of a workman of remarkable gifts, but of troubled vision; not unskillful, but made to appear unskillful by some manual infirmity.

Le Monde Illustré, Oct. 22, 1904 (Boisard): . . . A kind of art that might have been produced by a Zulu islander. . . .

La Revue Hebdomadaire, Oct. 22, 1904 (Péladan): . . . A curious phenomenon is taking place. The artist discards the Masters and, to use his own words, observes life. The critic, on the other hand, surrounds himself with masterpieces, and has a veritable Pinacothek at home composed of prints by Braum. "You spend too much time in Rue Louis le Grand," [1] said one of the exhibitors by way of concluding a dispute about Cézanne. What is this art, pray, which suffers so grievously from a knowledge of the masters, and study of their masterpieces?

Encyclopédie Contemporaine, Oct. 25, 1904 (Benedict):

[1] Where Braun & Co. is situated in Paris. (*Trans. Note*)

. . . Monsieur Cézanne with his contrasting paint and his problematical drawing is a painter whom we shall never be able to understand; the enthusiasm that he had aroused in the new school will always be an enigma to us.

La Petite Gironde, October, 1904: . . . Cézanne is not misunderstood—he is just incomplete. We have known him these thirty years. It did not require thirty years for others who were misunderstood to become celebrated: Millet, Daubigny, Theodore Rousseau; nor for them to dictate their own terms and to have their triumph.

Les Débats, Nov. 4, 1904 (Sarradin) : . . . I should not know today how to prepare a defense of Cézanne. . . . The impression given by all these clumsily daubed portraits is truly painful; they bear witness to a fatal impotence. This exhibition does considerable wrong to a man who, although certainly not a leader of a school as some would have him, has at least signed some still-lifes and landscapes which, in spite of their unskillful execution, one can enjoy for their naïve talents of observation and color.

La Revue Bleue, Nov. 5, 1904 (Bouyer) : . . . Ah!! Cézanne! "Blessed be the poor in spirit, for the kingdom of art is theirs!" . . . Come, now, tell us, spoiled as we may be, why compose, draw—why paint at all? Why try to *know,* when it is so voluptuous to *feel?* Why talk of education, training, learning, if art is immediate, impulsive, dumb, and mad like a savage?

Le Clairon, Nov. 13, 1904 (Norval) : . . . Paul Cézanne, disconcerting because of annoying incoherence of drawing and undeniable qualities of paint.

L'Univers, Nov. 14, 1904 (Le Say) : . . . The works of Paul Cézanne here gathered together are more amazing than one could possibly dream; they are false, they are brutal, they are mad. I say it in a whisper, for it is very dangerous to

pronounce such an opinion in public; nobody knows that better than the poor chap who, at the time of the presidential visit, was beaten up because he did not show sufficient enthusiasm in this chamber of horrors.

La Critique, Nov. 20, 1904 (Alcanter de Brahm) : . . . In another room Cézanne has his triumph; disciple of the Pissarros and the Monets.

La Revue Libre, November, 1904 (Horus) : . . . A regrettable error in the catalogue places Cézanne before Puvis de Chavannes, on a derisive alphabetical pretext.

2. Salon d'Automne of 1905

Les Débats, Oct. 5, 1905 (Sarradin) : . . . There are Cézannes like all other Cézannes. . . . Yes. . . . Yes. . . .

Le Journal, Oct. 17, 1905 (Gustave Geffroy) : . . . We must learn not to imitate Cézanne, but Cézanne's scrupulousness in the presence of Nature.

Echo de Paris, Oct. 17, 1905 (Babin) : . . . Monsieur Cézanne, with several works representative of his undeniable qualities and his too evident faults.

New York Herald, Paris edition, Oct. 17, 1905 (Weber) : . . . One must be a painter to understand Monsieur Cézanne; one must have acquired a distaste for craftsmanship, for tradition, for preachments, and for theories. But there is, we are told, a superior affirmation of art in Monsieur Cézanne's voluntary ignorance and painful researches. We could readily believe it if this sublime ignoramus had not studied the eighteenth century painters so much; the high-priest of deliberate unskillfulness has no such disdain of "imitation."

La République Française, Oct. 17, 1905 (de Bettex) : . . . Let us leave others to admire the monkeys *à la Cézanne,* painted with mud, not to say worse.

Le Matin, Oct. 17, 1905 : . . . The portrait of a woman

and the landscapes by Monsieur Paul Cézanne, together with the splendid paintings by Monsieur Abel Faivre, deserve to be mentioned in the first rank.

L'Eclair, Oct. 17, 1905 (R. M. Ferry) : . . . It must at least be admitted that Monsieur Cézanne is a painter endowed with singular talents, but aside from these talents he knows almost nothing about the art of painting.

Le Figaro, Oct. 17, 1905 (Arsène Alexandre) : . . . Cézanne, so ably championed nowadays that there is nothing left for us to say.

Le Petit Journal, Oct. 17, 1905 : . . . Monsieur Cézanne, whose work ravishes certain collectors. We do not care to insist upon the point, not being one of their number.

La Liberté, Oct. 17, 1905 (Etienne Charles) : . . . Are his "Bathers" sincere? If they are, we pity the artist—an unconscious mystifier.

Le XIXe Siècle, Oct. 18, 1905 : . . . Among the masters of yesterday, we must mention Cézanne, who paints still-life with facility.

L'Intransigeant, Oct. 18, 1905 (D'Anner) : . . . Of Monsieur Cézanne I shall say nothing; his art—for it seems it *is* art—is beyond our humble comprehension.

La Petite Gironde, Oct. 18, 1905 : . . . Monsieur Cézanne is disconcerting to a mind not forewarned. This year I look in vain at his *Harvesters,* his hideous *Bathers,* his childish landscapes, and I cannot find the mysterious genius in them. In vain I cry, "Cézanne show thyself !"

La Lanterne, Oct. 19, 1905 : . . . What use have we now for Monsieur Cézanne? Is his cause really not understood? Do not all who have seen his works consider him an irremediable failure? So much the worse for the dealers who took Zola's word and believed that some day they would make a

clean-up with his works. Let Monsieur Vollard accept the inevitable! . . .

La Revue Bleue, Oct. 21, 1905 (Camille Mauclair) : . . . Monsieur Cézannes exhibits several things which are as dull, clumsy, and ugly, but also as naïve and sincere, as usual. There is notably a view of Estaque which travesties that adorable panorama of gold and sapphire by making it a sullen swamp of leaden blue where never a ray of sunlight could have shone; also some fruit on a dirty cloth, and a scene with unnatural nudes. . . .

Le Petit Dauphinois, Oct. 25, 1905 (Bernard) : . . . At the risk of being called a fossil, I must permit myself to affirm that in my eyes Cézanne's *Bathers,* in which there is neither idea, nor drawing, nor color, does not constitute the last word in painting.

Le Chroniqueur Mondain, Oct. 26, 1905 (Henry Asselin) : . . . Cézanne, another of the incomprehensibles, who will probably always remain a "great man misunderstood," is the most disconcerting of the *fantaisistes* of genius.

La Dépêche, Oct. 28, 1905: . . . His *Bathers,* badly arranged and badly modelled, his landscapes far too off-hand, can be appreciated only by the initiated; I am not one of their number.

La Revue Hebdomadaire, Oct. 28, 1905 (Péladan) : . . . Monsieur Cézanne sends his portrait! What a good man he is! He looks like a pensive laborer. Why does he ever try to do anything but still-life when he simply doesn't know how?

Le Tintamarre, Nov. 5, 1905 (Lestrange) : . . . At the Salon d'Automne the eye must needs become eclectic to admire the ingenuous art of a Cézanne.

Journal de Rouen, Nov. 6, 1905 (Nicolle) : . . . Pastures and people, a little world all by itself clumsily cut out of

wood and daubed up with cheap and garish colors like the humble toys at a bazaar.

Le Journal des Arts, Nov. 11, 1905 (de Saint-Hilaire) : . . . The landscapes of Monsieur Paul Cézanne . . . their style redeems a singularly puerile and childish character.

Mercure de France, Dec. 1, 1905 (Ch. Morice) : . . . Paul Cézanne's pictures frighten the public and delight the artists; all the public, not all the artists. I do not think that the affinity between Cézanne and a poet would be very complete. A painter. Is he a painter in the fullest sense of the word? For if he were, the affinity between him and a poet *would* be warm.

Art et Décoration, December, 1905 (François Monod) : . . . Monsieur Cézanne is a belated primitive, not a Millet, on a smaller scale, (or, other things being equal, a Verlaine of painting), but a sort of Crainquebille gifted as a colorist who, by dint of isolation and a persistent awkwardness, has had a few strokes of good luck.

La Revue, Dec. 15, 1905 (Camille Mauclair) : . . . As for Monsieur Cézanne, his name will be connected for all time with the most memorable artistic pleasantry of the past fifteen years. It took some of the "cockney impudence" of which Mr. Ruskin spoke to invent the "genius" of this good old man who paints for his pleasure in the provinces and produces heavy, ill-constructed, and conscientiously haphazard works: Still-life rather good in form but rather crude in color, leaden landscapes, figures which a journalist recently described as "michelangelesque," and all of them quite simply the shapeless attempts of a man who has more good-will than knowledge. But the eulogies are not all due to "cockneys" or simpletons. We find them after the names of men who knew enough to put Carrière and Besnard before the world. . . . Such an attitude in the presence of a painter like Mon-

sieur Cézanne constrains one to protest violently against him of whom we merely ask not to have to say a single word, because he has never produced what one can call a work.

3. Salon d'Automne of 1906

Death of Cézanne (October 22, 1906)

New York Herald, Paris edition, Oct. 5, 1906 (Pierre Weber) : Monsieur Cézanne has been called a "sublime ignoramus." But there is some little disagreement about the definition; some would omit the "sublime," and some would omit the "ignoramous."

Le Gil Blas, Oct. 5, 1906 (Vauxelles) : . . . To deny that Cézanne is one of the most conscientious, one of the most sober, and one of the most obstinately persistent masters of today, is to deny the evidence. To treat him as an "ingenuous bricklayer," "a fierce and bizarre imagier," [2] who "sees nature cross-eyed,"[3] is no longer tenable. Really, the joke has lasted too long. On the other hand, who the devil thinks of denying his defects? Irregularity, violent contrasts, unskillfulness; wrapped forms, backgrounds that come forward, planes that pitch and toss; portraits of crooked ugly louts. We know all that. But has Rubens taste; has Renoir ideas?

La République Française, Oct. 5, 1906 (de Bettex) : . . . Cézanne's portraits would tickle one's ribs at a Punch and Judy show.

La Liberté, Oct. 7, 1906 (Etienne Charles) : . . . Monsieur Cézanne scorns the graces of color and form.

Le Figaro, Oct. 25, 1906 (Arsène Alexandre) : . . . What strikes every impartial observer on examining a canvas by Cézanne, is, apart from the incontestable nobility of the con-

[2] Imagier d'Epinal. A maker of naïve but expressive woodcuts that are printed in colors. (*Trans. Note*)
[3] Literally "sees nature hump-backed."

ception and of the "point of departure," an absolute impo-
tence to arrive at his goal. Only those arrive at their goal
who can express and perpetuate the emotion that they have
felt. Art cannot be enriched simply by good intentions.

Le Temps, Oct. 25, 1906 (Thiébault-Sisson) : . . . To tell
the truth, his pictures are little more than sketches. It is not
so much from negligence or willfulness as it is due to the
conformation of his eye which will not permit him to push
the most promising sketch to a conclusion.

Le Gaulois, Oct. 25, 1906 : . . . Paul Cézanne, the revo-
lutionary *pleinairiste* has just passed away. . . . His artistic
education (one can hardly believe it) was obtained entirely
in the Louvre, where he spent many long years copying the
eighteenth century masters whose beauties were revealed to
him by his artistic temperament.

L'Eclair, Oct. 25, 1906 (René-Marc Ferry) : . . . An in-
complete talent, whose imperfect vision kept his work un-
developed and always in the state of a sketch. Thanks to the
perversity of certain writers and the artifices of certain deal-
ers he cut a brave figure as a great man and a *chef d'école.*

Le Soleil, Oct. 25, 1906 : . . . Cézanne was a very fine
man, highly esteemed by all who knew him, but a very in-
complete artist. They tried to make a master of him, but
their efforts were unsuccessful; the public would not give
the stamp of its approval to an infatuation which had nothing
to justify it. The most admirable thing in the life of "Father
Cézanne" was his perseverance in painting badly.

Journal de Monaco, Oct. 30, 1906: . . . Cézanne forced
himself to paint people, landscapes and still-lifes just as he
saw them, without troubling himself about imparting to them
a little beauty. Faces, trees, flowers, fruit, or furniture were
bungled with the same brutality.

Bulletin de l'Art Ancien et Moderne, Nov. 3, 1906: . . . Cézanne was accepted as a master by a group of the younger generation who tried to make him out a *chef d'école.* As for the public, it never ceased being disconcerted by this sincere but incomplete artist's weakness in drawing.

La Revue des Beaux-Arts, Nov. 11, 1906 (Fagus): . . . Dare I say that he had as much genius as a savage. . . .

L'Art et les Artistes, November, 1906 (Guillemot): . . . Some go as far as to pretend that he was a man of genius; business reasons alone might justify such an exaggeration.

Art et Décoration, November, 1906 (Mauclair): When Cézanne was alive, certain things might be said of him. Over his fresh closed grave it but becomes me to admit with regret that I was never able to discover the reasons for his influence, and to add a tribute to the modest good-will of this persevering and ill-starred artist.

Mercure de France, Feb. 15, 1907 (Charles Morice compares Gauguin's exile in Tahiti with Cézanne's voluntary seclusion at Aix):

"Gauguin's exile was not the gesture of a man separating himself from his kind. . . . In avoiding a 'false semblance of civilization,' far from turning away from life, he found it. . . .

"Cézanne, cloistered within the strict limits of the technique of his art, living by his eye and brain alone, strikes us as the prototype of the one-track mind, egotistically incurious about all that did not have to do with tones and the relations of tones—a magnificent monster."

Le Feu, May, 1912 (Joachim Gasquet): . . . He possessed the accurate mysticism of reality, and his torment was to render life yet more living. He sits himself down in the corner of a tavern, drinks a finger of heavy wine, and slowly the soul of Shakespeare, which haunts him, weaves a ro-

mantic drama out of the uncouth converse of the peasants. A wisp of a girl, like an elusive *ignis fatuus,* trips along the edge of the ever open grave which follows his stumbling footsteps, and into which, as soon as ecstasy comes, vanish the misty remains of his cares. A *motif* springs into being.

PAUL CÉZANNE
by Roger Fry

(A review of Vollard's *Paul Cézanne* originally
published in *Burlington Magazine*, 1917).

In a society which is as indifferent to works of art as our modern
industrialism it seems paradoxical that artists of all kinds should loom
so large in the general consciousness of mankind—that they should
be remembered with reverence and boasted of as national assets
when statesmen, lawyers, and soldiers are forgotten. The great mass
of modern men could rub along happily enough without works of art
or at least without new ones, but society would be sensibly more
bored if the artist died out altogether. The fact is that every honest
bourgeois, however sedate and correct his life, keeps a hidden and
scarce-admitted yearning for that other life of complete individualism
which hard necessity or the desire for success has denied him. In
contemplating the artist he tastes vicariously these forbidden joys.
He regards the artist as a strange species, half idiot, half divine, but
above all irresponsibly and irredeemably himself. He seems equally
strange in his outrageous egoism and his superb devotion to an idea.

Also in a world where the individual is squeezed and moulded and
polished by the pressure of his fellow-men the artist remains irre-
claimably individual—in a world where every one else is being
perpetually educated the artist remains ineducable—where others
are shaped, he grows. Cézanne realised the type of the artist in its
purest, most unmitigated form, and M. Vollard has had the wit to
write a book about Cézanne and not about Cézanne's pictures. The
time may come when we shall require a complete study of Cézanne's
work, a measured judgment of his achievement and position—it

would probably be rash to attempt it as yet. Meanwhile we have M. Vollard's portrait, at once documented and captivating. Should the book ever become as well known as it deserves there would be, one guesses, ten people fascinated by Cézanne for one who would walk down the street to see his pictures.

The art historian may sometimes regret that Vasari did not give us more of the aesthetics of his time; but Vasari knew his business, knew, perhaps, that the aesthetics of an age are quickly superseded but that the human document remains of perennial interest to mankind. M. Vollard has played Vasari to Cézanne and done so with the same directness and simplicity, the same narrative ease, the same insatiable delight in the oddities and idiosyncrasies of his subject. And what a model he had to paint! Every word and every gesture he records sticks out with the rugged relief of a character in which everything is due to the compulsion of inner forces, in which nothing has been planed down or smoothed away by external pressure—not that external pressure was absent but that the inner compulsion—the inevitable bent of Cézanne's temperament, was irresistible. In one very important detail Cézanne was spared by life—he always had enough to live on. The thought of a Cézanne having to earn his living is altogether too tragic. But if life spared him in this respect his temperament spared him nothing—for this rough Provençal countryman had so exasperated a sensibility that the smallest detail of daily life, the barking of a dog, the noise of a lift in a neighbouring house, the dread of being touched even by his own son might produce at any moment a nervous explosion. At such times his first relief was in cursing and swearing, but if this failed the chances were that his anger vented itself on his pictures—he would cut one to pieces with his palette knife, or failing that roll it up and throw it into the stove. M. Vollard describes with delightful humour the tortures he endured in the innumerable sittings which he gave Cézanne for his portrait—with what care he avoided any subject of conversation which might lead to misunderstanding. But with all his adroitness there were one or two crises in which the portrait was threatened with the dreaded

knife—fortunately Cézanne always found some other work on which to vent his indignation, and the portrait survived, though after a hundred and fifteen sittings, in which Cézanne exacted the immobility of an apple, the portrait was left incomplete. "I am not displeased with the shirt front," was Cézanne's characteristic appreciation.

Two phrases continually recur in Cézanne's conversation which show his curious idiosyncrasies. One the often-quoted one of his dread that any one might *"lui jeter le grappin dessus"* and the other *"moi qui suis faible dans la vie."* They express his constant attitude of distrust of his kind—for him all women were *"des veaux et des calculatrices"*—his dread of any possible invasion of his personality, and his sense of impotence in face of the forces of life.

None the less, though he pathetically exaggerated his weakness he never seems to have had the least doubt about his supreme greatness as an artist; what troubled and irritated him was his incapacity to express his "sensation" in such terms as would make its meaning evident to the world. It was for this reason that he struggled so obstinately and hopelessly to get into the "Salon de M. Bouguereau." His attitude to conventional art was a strange mixture of admiration at its skill and of an overwhelming horror of its emptiness—of its so "horrible resemblance."

That fact is that Cézanne had accepted uncritically all the conventions in the pathetic belief that it was the only way of safety for one "so feeble in life." So he continued to believe in the Catholic Church not from any religious conviction but because "Rome was so strong"—so, too, he believed in the power and importance of the "Salon de Bouguereau" which he hated as much as he feared. So, too, with what seems a paradoxical humility he let it be known, when his fame had already been established among the intelligent, that he would be glad to have the Legion of Honour. But here, too, he was destined to fail. The weighty influence and distinguished position of his friends could avail nothing against the undisguised horror with which any official heard the dreaded name of Cézanne. And it

appeared that Cézanne was the only artist in France for whom this distinction was inaccessible, even through "influence." Nothing is stranger in his life than the contrast between the idea the public formed of Cézanne and the reality. He was one of those men destined to give rise to a legend which completely obscured the reality. He was spoken of as the most violent of revolutionaries—Communard and Anarchist were the favourite epithets—and all the time he was a timid little country gentleman of immaculate respectability who subscribed whole-heartedly to any reactionary opinion which might establish his "soundness." He was a timid man who really believed in only one thing, "his little sensation"; who laboured incessantly to express this peculiar quality and who had not the faintest notion of doing anything that could shock the feelings of any mortal man or woman. No wonder then that when he looked up from his work and surveyed the world with his troubled and imperfect intellectual vision he was amazed and perturbed at the violent antagonism which he had all unconsciously provoked. No wonder that he became a shy, distrustful misanthrope, almost incapable of any association with his kind.

I have suggested that Cézanne was the perfect realisation of the type of the artist—I doubt whether in the whole of Vasari's great picture gallery there is a more complete type of "original." But in order to accept this we must banish from our mind the conventional idea of the artist as a man of flamboyant habits and calculated pose. Nothing is less possible to the real artist than pose—he is less capable of it than the ordinary man of business because more than any one else his external activities are determined from within by needs and instincts which he himself barely recognises.

On the other hand the imitation artist is a past master of pose, he poses as the sport of natural inclinations whilst he is really deliberately exploiting his caprices; and as he has a natural instinct for the limelight this variety of the "Cabotin" generally manages to sit for the portrait of the artist. Cézanne then, though his external life was that of the most irreproachable of country gentlemen, though he went to mass every Sunday and never willingly left the intimacy of family life,

was none the less the purest and most unadulterated of artists, the most narrowly confined to his single activity, the most purely disinterested and the most frankly egoistic of men.

Cézanne had no intellectual independence. I doubt if he had the faintest conception of intellectual truth, but this is not to deny that he had a powerful mind. On the contrary he had a profound intelligence of whatever came within his narrow outlook on life, and above all he had the gift of expression, so that however fantastic, absurd, or naïve his opinions may have been, they were always expressed in such racy and picturesque language that they become interesting as revelations of a very human and genuine personality.

One of the tragi-comedies of Cézanne's life was the story of his early friendship with Zola, followed in middle life by a gradual estrangement, and at last by a total separation. It is perhaps the only blot in M. Vollard's book that he has taken too absolutely Cézanne's point of view, and has hardly done justice to Zola's goodness of heart. The cause of friction, apart from Cézanne's habitual testiness and ill-humour, was that Zola's feeling for art, which had led him in his youth to a heroic championship of the younger men, faded away in middle life. His own practice of literature led him further and further away from any concern with pure art, and he failed to recognise that his own early prophecy of Cézanne's greatness had come true, simply because he himself had become a popular author, and Cézanne had failed of any kind of success. Unfortunately Zola, who had evidently lost all real aesthetic feeling, continued to talk about art, and worse than that he had made the hero of "L'Œuvre" a more or less recognisable portrait of his old friend. Cézanne could not tolerate Zola's gradual acquiescence in worldly ideals and ways of life, and when the Dreyfusard question came up not only did his natural reactionary bias make him a vehement anti-Dreyfusard but he had no comprehension whatever of the heroism of Zola's actions; he found him merely ridiculous, and believed him to be engaged in an ill-conceived scheme of self-advertisement. But for all his contempt of Zola his affection remained deeper than he knew, and when he heard the

news of Zola's death Cézanne shut himself up alone in his studio, and was heard sobbing and groaning throughout the day.

Cézanne's is not the only portrait in M. Vollard's entertaining book—there are sketches of many characters, among them the few strange and sympathetic men who appreciated and encouraged Cézanne in his early days. Of Cabaner the musician M. Vollard has collected some charming notes. Cabaner was a "philosopher," and singularly indifferent to the chances of life. During the siege of Paris he met Coppée, and noticing the shells which were falling he became curious. "Where do all these bullets come from?" Coppée: "It would seem that it is the besiegers who send them." Cabaner, after a silence: "Is it always the Prussians?" Coppée, impatiently: "Who on earth could it be?" Cabaner: "I don't know . . . other nations!" But the book is so full of good stories that I must resist the temptation to quote.

Fortunately M. Vollard has collected also a large number of Cézanne's *obiter dicta* on art. These have all Cézanne's pregnant wisdom and racy style. They often contain a whole system of aesthetics in a single phrase, as, for instance: "What's wanted is to do Poussin over again from Nature."

They show, moreover, the natural bias of Cézanne's feelings and their gradual modification as his understanding became more profound. What comes out clearly, and it must never be forgotten in considering his art, is that his point of departure was from Romanticism. Delacroix was his god and Ingres, in his early days, his devil— a devil he learned increasingly to respect, but never one imagines really to love, *"Ce Dominique est très fort mais il m'emm——."* That Cézanne became a supreme master of formal design every one would nowadays admit, but there is some excuse for those contemporaries who complained of his want of drawing. He was not a master of line in the sense in which Ingres was. "The contour escapes me," as he said. That is to say he arrived at the contour by a study of the interior planes; he was always plastic before he was linear. In his early works, such, for instance, as the "Scène de plein air," he is evidently

inspired by Delacroix; he is almost a romanticist himself in such work, and his design is built upon the contrasts of large and rather loosely drawn silhouettes of dark and light. In fact it is the method of Tintoretto, Rubens, and Delacroix.

In the "Bathers resting," painted in 1877, there is already a great change. It is rather by the exact placing of plastic units than by continuous flowing silhouettes that the design holds. Giorgione perhaps, is behind this, but no longer Tintoretto, and, above all, Poussin has intervened.

In later works, such as the portrait of "Mme. Cézanne in a greenhouse" [*Madame Cézanne in the Conservatory*], the plasticity has become all-important, there is no longer any suggestion of a romantic *decor*; all is reduced to the purest terms of structural design. . . .

When the time comes for the complete appreciation of Cézanne, M. Vollard's book will be the most important document existing. It should, however, have a far wider appeal than that. I hope that after the war M. Vollard will bring out a small cheap edition*—it should become a classic biography. To say, as I would, that M. Vollard's book is a monument worthy of Cézanne himself is to give it the highest praise.

*This has been done. *Paul Cézanne*, by Ambroise Vollard (Paris).

A CATALOG OF SELECTED
DOVER BOOKS
IN ALL FIELDS OF INTEREST

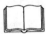

A CATALOG OF SELECTED DOVER
BOOKS IN ALL FIELDS OF INTEREST

DRAWINGS OF REMBRANDT, edited by Seymour Slive. Updated Lippmann, Hofstede de Groot edition, with definitive scholarly apparatus. All portraits, biblical sketches, landscapes, nudes. Oriental figures, classical studies, together with selection of work by followers. 550 illustrations. Total of 630pp. 9⅛ × 12¼.
21485-0, 21486-9 Pa., Two-vol. set $25.00

GHOST AND HORROR STORIES OF AMBROSE BIERCE, Ambrose Bierce. 24 tales vividly imagined, strangely prophetic, and decades ahead of their time in technical skill: "The Damned Thing," "An Inhabitant of Carcosa," "The Eyes of the Panther," "Moxon's Master," and 20 more. 199pp. 5⅜ × 8½. 20767-6 Pa. $3.95

ETHICAL WRITINGS OF MAIMONIDES, Maimonides. Most significant ethical works of great medieval sage, newly translated for utmost precision, readability. Laws Concerning Character Traits, Eight Chapters, more. 192pp. 5⅜ × 8½.
24522-5 Pa. $4.50

THE EXPLORATION OF THE COLORADO RIVER AND ITS CANYONS, J. W. Powell. Full text of Powell's 1,000-mile expedition down the fabled Colorado in 1869. Superb account of terrain, geology, vegetation, Indians, famine, mutiny, treacherous rapids, mighty canyons, during exploration of last unknown part of continental U.S. 400pp. 5⅜ × 8½. 20094-9 Pa. $6.95

HISTORY OF PHILOSOPHY, Julián Marías. Clearest one-volume history on the market. Every major philosopher and dozens of others, to Existentialism and later. 505pp. 5⅜ × 8½. 21739-6 Pa. $8.50

ALL ABOUT LIGHTNING, Martin A. Uman. Highly readable non-technical survey of nature and causes of lightning, thunderstorms, ball lightning, St. Elmo's Fire, much more. Illustrated. 192pp. 5⅜ × 8½. 25237-X Pa. $5.95

SAILING ALONE AROUND THE WORLD, Captain Joshua Slocum. First man to sail around the world, alone, in small boat. One of great feats of seamanship told in delightful manner. 67 illustrations. 294pp. 5⅜ × 8½. 20326-3 Pa. $4.50

LETTERS AND NOTES ON THE MANNERS, CUSTOMS AND CONDITIONS OF THE NORTH AMERICAN INDIANS, George Catlin. Classic account of life among Plains Indians: ceremonies, hunt, warfare, etc. 312 plates. 572pp. of text. 6⅛ × 9¼. 22118-0, 22119-9 Pa. Two-vol. set $15.90

ALASKA: The Harriman Expedition, 1899, John Burroughs, John Muir, et al. Informative, engrossing accounts of two-month, 9,000-mile expedition. Native peoples, wildlife, forests, geography, salmon industry, glaciers, more. Profusely illustrated. 240 black-and-white line drawings. 124 black-and-white photographs. 3 maps. Index. 576pp. 5⅜ × 8½. 25109-8 Pa. $11.95

CATALOG OF DOVER BOOKS

AMERICAN CLIPPER SHIPS: 1833–1858, Octavius T. Howe & Frederick C. Matthews. Fully-illustrated, encyclopedic review of 352 clipper ships from the period of America's greatest maritime supremacy. Introduction. 109 halftones. 5 black-and-white line illustrations. Index. Total of 928pp. 5⅜ × 8½.
25115-2, 25116-0 Pa., Two-vol. set $17.90

TOWARDS A NEW ARCHITECTURE, Le Corbusier. Pioneering manifesto by great architect, near legendary founder of "International School." Technical and aesthetic theories, views on industry, economics, relation of form to function, "mass-production spirit," much more. Profusely illustrated. Unabridged translation of 13th French edition. Introduction by Frederick Etchells. 320pp. 6⅛ × 9¼. (Available in U.S. only)
25023-7 Pa. $8.95

THE BOOK OF KELLS, edited by Blanche Cirker. Inexpensive collection of 32 full-color, full-page plates from the greatest illuminated manuscript of the Middle Ages, painstakingly reproduced from rare facsimile edition. Publisher's Note. Captions. 32pp. 9⅜ × 12¼.
24345-1 Pa. $4.50

BEST SCIENCE FICTION STORIES OF H. G. WELLS, H. G. Wells. Full novel *The Invisible Man,* plus 17 short stories: "The Crystal Egg," "Aepyornis Island," "The Strange Orchid," etc. 303pp. 5⅜ × 8½. (Available in U.S. only)
21531-8 Pa. $4.95

AMERICAN SAILING SHIPS: Their Plans and History, Charles G. Davis. Photos, construction details of schooners, frigates, clippers, other sailcraft of 18th to early 20th centuries—plus entertaining discourse on design, rigging, nautical lore, much more. 137 black-and-white illustrations. 240pp. 6⅛ × 9¼.
24658-2 Pa. $5.95

ENTERTAINING MATHEMATICAL PUZZLES, Martin Gardner. Selection of author's favorite conundrums involving arithmetic, money, speed, etc., with lively commentary. Complete solutions. 112pp. 5⅜ × 8½.
25211-6 Pa. $2.95

THE WILL TO BELIEVE, HUMAN IMMORTALITY, William James. Two books bound together. Effect of irrational on logical, and arguments for human immortality. 402pp. 5⅜ × 8½.
20291-7 Pa. $7.50

THE HAUNTED MONASTERY and THE CHINESE MAZE MURDERS, Robert Van Gulik. 2 full novels by Van Gulik continue adventures of Judge Dee and his companions. An evil Taoist monastery, seemingly supernatural events; overgrown topiary maze that hides strange crimes. Set in 7th-century China. 27 illustrations. 328pp. 5⅜ × 8½.
23502-5 Pa. $5.00

CELEBRATED CASES OF JUDGE DEE (DEE GOONG AN), translated by Robert Van Gulik. Authentic 18th-century Chinese detective novel; Dee and associates solve three interlocked cases. Led to Van Gulik's own stories with same characters. Extensive introduction. 9 illustrations. 237pp. 5⅜ × 8½.
23337-5 Pa. $4.95

Prices subject to change without notice.

Available at your book dealer or write for free catalog to Dept. GI, Dover Publications, Inc., 31 East 2nd St., Mineola, N.Y. 11501. Dover publishes more than 175 books each year on science, elementary and advanced mathematics, biology, music, art, literary history, social sciences and other areas.